Treasures
from Olana

LANDSCAPES BY

Frederic Edwin Church

ESSAY BY KEVIN J. AVERY

INTRODUCTION BY JOHN WILMERDING

THE OLANA PARTNERSHIP
HUDSON, NEW YORK

NEW YORK STATE OFFICE OF PARKS, RECREATION
AND HISTORIC PRESERVATION
ALBANY, NEW YORK

CORNELL UNIVERSITY PRESS
ITHACA AND LONDON

The exhibition *Treasures from Olana* was organized by The Olana Partnership and the New York State Office of Parks, Recreation and Historic Preservation, using objects from the collection of Olana State Historic Site, Hudson, New York.

Olana State Historic Site is one of 35 historic properties administered and operated by the New York State Office of Parks, Recreation and Historic Preservation; George E. Pataki, Governor.

Unless otherwise credited, all photographs and other visual images are courtesy of Olana State Historic Site, New York State Office of Parks, Recreation and Historic Preservation.

Library of Congress Control Number: 2005923228
ISBN: 0-8014-4430-6

First published 2005 by The Olana Partnership, New York, and Cornell University Press

Page 1: Andy Wainwright, *Olana, Northeast Corner*, photograph, 2004, © Andy Wainwright

Pages 2–3: Frederic Edwin Church, *Twilight, a Sketch*, 1858 (detail; cat. no. 4)

Pages 4–5: Frederic Edwin Church, *Rainbow near Berchtesgaden, Germany*, 1868 (detail; cat. no. 14)

Pages 6–7: Frederic Edwin Church, *Sunrise (The Rising Sun)*, October–December 1862 (detail), oil on canvas, $10\frac{1}{2} \times 17\frac{15}{16}$ in., OL.1981.12

Pages 8–9: Frederic Edwin Church, *Moonrise (The Rising Moon)*, 1865 (detail; fig. 23)

Page 67: Nicholas Whitman, *View from the Piazza, Olana*, photograph, 2001

Page 72: Peter Aaron, *View from the Bell Tower*, photograph, 1998, © Peter Aaron/Esto

Edited by Fronia W. Simpson
Designed by John Hubbard with assistance by Zach Hooker
Color separations by iocolor, Seattle
Produced by Marquand Books, Inc., Seattle
 www.marquand.com
Printed and bound by CS Graphics Pte., Ltd,, Singapore

Contents

Foreword

New York State is delighted to share the *Treasures from Olana* through the first-ever traveling exhibition of paintings and sketches by Frederic Edwin Church from the collection of Olana State Historic Site. We are grateful to The Olana Partnership, which made the exhibition possible through hard work and financial backing.

Olana—the house, collections, and landscape—is one of the treasures of New York State and has a long history of public-private partnership. In 1966 Olana was saved through the combined efforts of Olana Preservation—the predecessor of The Olana Partnership—and New York State, under the leadership of Governor Nelson Rockefeller. In recent years, a multimillion-dollar historic restoration has attracted tens of thousands of visitors each year, and Olana has become a must-see for visitors to the Hudson Valley National Heritage Area.

I am delighted that this selection of paintings will be seen by a wider New York State audience as the exhibition travels to The Fenimore Art Museum in Cooperstown and the National Academy Museum in New York City, and by a national audience in Houston, Texas; Portland, Maine; San Marino, California; and Princeton, New Jersey.

While this exhibition is traveling, exciting progress is taking place in the preservation of Olana. Through the combined funding efforts of New York State Office of Parks, Recreation and Historic Preservation and the National Endowment for the Humanities, a fire protection and climate management system is being installed at Olana, an important step to ensure the future of the house and collection.

George E. Pataki
Governor
State of New York

Preface and Acknowledgments

Treasures from Olana: Landscapes by Frederic Edwin Church represents an important new chapter in Olana's history as a New York State Historic Site. For the first time, a selection of paintings by Frederic Edwin Church, exhibited by the artist in his home, will travel from Olana State Historic Site to various museums around the country. Thanks to Exhibition Curator Kevin Avery and many others, the story of Church and his Olana will engage new friends across the nation. Collaborative projects such as this exhibit and the ongoing restoration of the main house at Olana, Cosy Cottage (the Church family's original home on the property), the nineteenth-century farm complex, and the artist-designed landscape represent a tremendous joint effort on the part of the New York State Office of Parks, Recreation and Historic Preservation (OPRHP) and its non-profit partner, The Olana Partnership. Together these two institutions are working to preserve and restore this vital Hudson River Valley asset.

We thank the following for their help with this exhibit: New York State Governor George E. Pataki; Office of Parks, Recreation and Historic Preservation Commissioner Bernadette Castro; Deputy Commissioner for Operations for the Hudson Valley James Moogan; Regional Director – Taconic Region Jayne McLaughlin; Regional Historic Preservation Supervisor Dennis Wentworth; and Olana Historic Site Manager Linda McLean. We are also grateful to The Olana Partnership staff members: President Sara Griffen; Associate Curator Valerie Balint; Librarian/Archivist Ida Brier; Vice President for Development Robert Burns; Development Associate Jennifer L. Conrad; Director of Administration and Public Affairs Kimberly Lamay; and Curator Evelyn Trebilcock.

The works in this exhibit have remained in Church's collection either on display in his New York City studios or at Church's home in Hudson since he painted them during the mid- to late 1800s. They are intimately bound to Olana—some representing the view from or of the property. As Kevin Avery observes in his essay, the paintings reflect

the aesthetics of the house through their "taste for spectacle—albeit natural spectacle—that so many of them evince." The importance of Church's painted treasures is that they are spectacular yet so true to life.

For this opportunity to experience Church's dramatic landscapes we are particularly grateful to Exhibition Curator Kevin Avery. We are also thankful to John Wilmerding for the introduction. For managing the loan and preparing the paintings and photographic materials for this publication, we are grateful to NYSOPRHP Peebles Island Resource Center: Director James Gold; Assistant Director John Lovell; Collections Manager Anne Cassidy and her staff Ronna Dixson and Mary Zaremski; Curator Robin Campbell; Photographer Richard Clauss; Paper Conservator Marie Culver; Paintings Conservator Joyce Zucker; and Frames Conservator Eric Price.

I want to recognize Franklin Kelly, Senior Curator American & British Paintings, National Gallery of Art, Elizabeth J. Broun, Director, Smithsonian American Art Museum, and Barry Harwood, Curator of Decorative Arts, Brooklyn Museum, for the generosity of their advice in the planning of this exhibition.

The catalogue, which guides us through this exhibition and tells the story of Frederic Church and Olana, would not have been possible without the assistance of Ed Marquand and his staff at Marquand Books. For supporting images we thank Arlene Sanderson and Caitlain LeDonne at the Carnegie Museum of Art; Mary Suzor and Monica Wolf at The Cleveland Museum of Art; Jill Bloomer at the Cooper-Hewitt, National Design Museum, Smithsonian Institution; Marianne Henein at the Corcoran Gallery of Art; Jacqueline Allen and Jeff Zilm at the Dallas Museum of Art; Sylvia Inwood at The Detroit Institute of Arts; Susan Grinols at the Fine Arts Museums of San Francisco; Colleen Zorn at A. J. Kollar Fine Paintings; Deanna Cross at The Metropolitan Museum of Art; Lorelei Eurto at the Munson-Williams-Proctor Arts Institute; Stacey Sherman at The Nelson-Atkins Museum of Art; Scott Hankins at The Newark Museum; Jennifer Walden at the New Britain Museum of American Art; Tom Lisanti and Stephan Sacks at The New York Public Library; Jennifer Belt at Art Resource; Joanna Hanna at the Springfield Museum Association; Nicole Rivette at The Toledo

Museum of Art; and Andrew Fotta at the Wadsworth Atheneum. For the contemporary photographs of Olana we thank Peter Aaron, Kurt Dolnier, Andy Wainwright, and Nicholas Whitman.

It is with pleasure that we share these "treasures" from Olana with new audiences as the collection travels to the Fenimore Art Museum; the Museum of Fine Arts, Houston; the National Academy Museum; the Portland Museum of Art; The Huntington Art Collections; and the Princeton University Art Museum. We would like to express our appreciation to the staffs at these institutions for making this possible.

Finally, we wish to thank the generous individual and institutional donors that provided the necessary funds that have made this important book and exhibition available to a greater audience: Jan P. and Warren J. Adelson; The Beulah Land Foundation; The Cape Branch Foundation; Valerie and Brock A. Ganeles; The Felicia Fund; David B. and Mimi G. Forer; Frederick D. Hill; Carol Irish; Gretchen and James L. Johnson; Mark LaSalle; The Henry Luce Foundation; The Lucelia Foundation; The Lunder Foundation; Peter and Paula Lunder; Pauline Metcalf; Richard and Elizabeth Gosnell Miller; The New York State Council on the Arts; Susan and Washburn S. Oberwager; Louis M. Salerno; The Olana Partnership's Strabo Council; Eli Wilner & Company, NYC; and Susan Winokur and Paul Leach. We are grateful to Charles Ruger, Trustee and Chair of Olana's Development Committee, for his assistance in our fund-raising efforts. For their generous advice and assistance, we also wish to express our appreciation to the capable and genial staffs of the institutions that provided support for this exhibit, including: Ellen Holtzman of The Henry Luce Foundation; and Kristin Herron, Fabiana Chiu-Rinaldi, and Melissa Rachleff of the Museum Program at the New York State Council on the Arts.

The legacy of Frederic Church takes form in a myriad of views. Those presented in this exhibit inspire us to appreciate the panorama of natural landscapes that can exist even within the walls of a museum gallery.

Jazz Johnson Merton
Chairman, The Olana Partnership

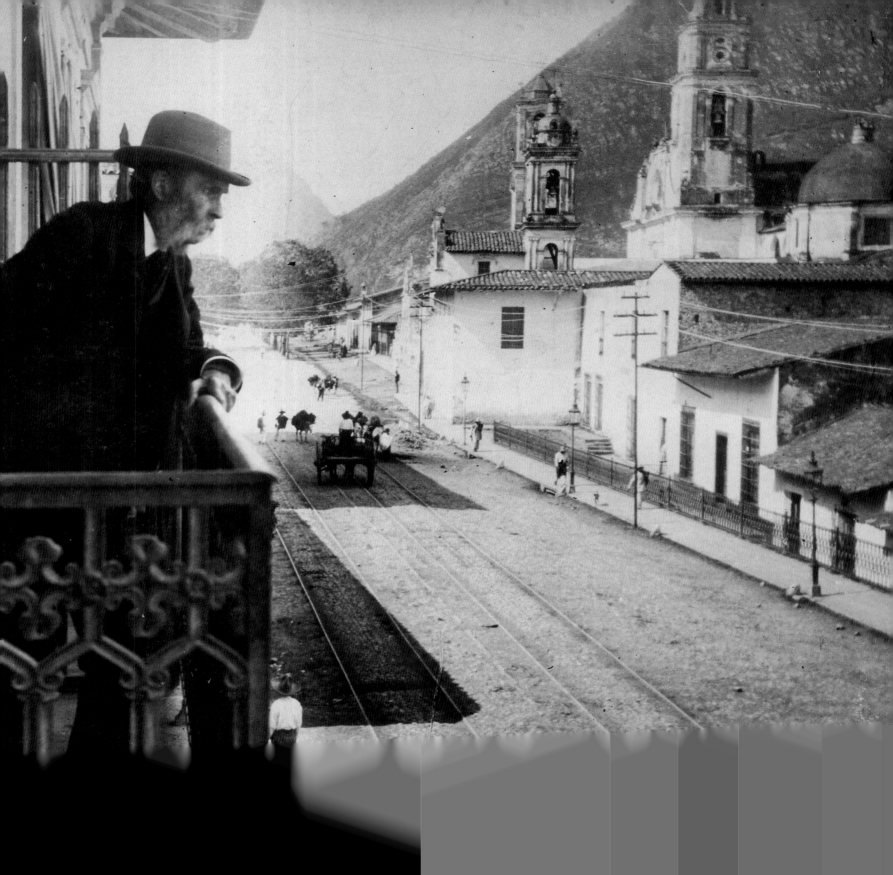

John Wilmerding

The Many Views of Frederic Edwin Church

Of all the major American artists of the mid-nineteenth century—Fitz Hugh Lane, Martin Johnson Heade, William Trost Richards—to have been rediscovered and reevaluated beginning in the 1960s, none has had a more dramatic and significant change in reputation than Frederic Edwin Church. Quite simply, he has gone from a figure in almost total obscurity to one seen as America's greatest artist before Winslow Homer and Thomas Eakins. Thomas Cole used to occupy that position of prominence in the early twentieth century, by virtue of his role as founding father of the Hudson River School. But in large measure due to the scholarly efforts and passionate role in the campaign to save Church's house, Olana, David Huntington is the modern hero who more than any other is responsible for bringing Church and his art to our attention and for defining the intellectual terms with which to appreciate his achievement. While a younger generation of scholars has continued to add to the Church literature in substantial ways, almost everything written in recent decades is indebted to the foundations of Huntington's work in the mid-1960s.

The circulation of selections from Church's private collection of his own paintings at Olana is an important occasion for many reasons, not least that of giving a wider public a chance to see firsthand a group of pictures intensely beautiful in their own right. Their wide variety shows the master in all phases of his career, in sketches and finished paintings, depicting the breadth of his subjects and the high technical skill that established him as an eminent and influential artist in his own time. Church was a prodigious draftsman, sketcher, and painter, well represented in this gathering. But even more, as works he held on to or reacquired and kept in his house during his lifetime, they embody the heart of his artistic vision and convey a deeply personal slant on an otherwise well-known public production. As pictures he hung and lived with at Olana, they tell the larger story of that extraordinary place and are as illuminating when seen in context as on their own. We need briefly to consider the multiple contextual layers

Walter Launt Palmer, *Church on a Balcony in Orizaba, Mexico,* 1895 (detail; see fig. 36)

of these works: their place in the larger setting of Olana's architecture and its surrounding landscape, and the near miraculous fact that Olana was saved at all. For if it had not been preserved, our understanding of Church and his aesthetic would be greatly diminished.

In the Olana archives is the transcript of an interview taped on 27 March 1988 with David Huntington, shortly before his death. First a professor of art history at Smith College from 1955 to 1966 and then for more than two decades at the University of Michigan, Huntington recounted the almost breathtaking story of his involvement in rescuing Olana from the auction houses and the imminent dispersal of its contents. He had entered Princeton University as a freshman in the fall of Pearl Harbor; his program was soon accelerated and then interrupted by the war. After doing service, some travel and work, Huntington completed his undergraduate degree, majoring first in architecture but shifting to art and archaeology. Taking a course with Donald Drew Egbert was his introduction to early modern art and architecture in Europe and America, the latter a subject largely ignored and disdained in most college curricula. In 1950 he enrolled in Yale's graduate program, where he encountered the charismatic teaching of Vincent Scully and George Heard Hamilton, who encouraged him to take on the virtually unknown figure of Frederic Edwin Church for a dissertation subject. During the fall of 1953 Huntington began more than a decadelong immersion in the contents of Olana, consisting of Church's enormous holdings of books, photographs, works he had collected by his contemporaries such as Martin Johnson Heade, and an accumulation of some seven hundred of his own drawings, oil sketches, and finished canvases. With the thesis completed and a book publication in mind, fate intervened in 1964 with the death of the artist's daughter-in-law, Mrs. Louis P. Church, the last relative still living at Olana. Uninterested in keeping that property, the next generation of descendants decided to sell it all.

Over the next two years Huntington cajoled patrons, politicians, and the press into paying attention to Olana and ultimately preserving it. He assisted in organizing the first modern exhibition of Church's work in 1966 and at the same time published the first definitive monograph on the artist, all of which coincided with the acquisition of the property by New York State. Not only had everything of Church's within the house been saved, very little had been rearranged since his lifetime, leaving for us today a rare house and studio of a major nineteenth-century American artist intact. Few others of comparable importance survive: one thinks of Winslow Homer's studio (stripped of most of its original contents) at Prout's Neck, Maine; the Thomas Eakins house in Philadelphia; Chesterwood, the sculptor Daniel Chester French's property in Stockbridge, Massachusetts; Fitz Hugh Lane's empty house in Gloucester, Massachusetts; the restored houses of Church's contemporaries Jasper Francis Cropsey and Thomas Cole, also on the

Frederic Edwin Church, *Tropical Vines and Trees, Jamaica*, ca. May–July 1865 (detail; see cat. no. 10)

Hudson River; and John F. Peto's house-studio, now threatened, in Island Heights, New Jersey. In quality and significance as an artist's residence, Olana best compares with Thomas Jefferson's Monticello in Charlottesville, Virginia, in the eighteenth century, and Frank Lloyd Wright's Taliesen in Spring Green, Wisconsin, in the twentieth. Like them, Olana crowns its hillside as a quintessential architectural autobiography of its creator.

By 1976 Church's reputation was such that his great painting *Niagara* (1857; see fig. 15), was placed on the cover of the catalogue for the Museum of Modern Art's ambitious bicentennial exhibition, *The Natural Paradise: Painting in America, 1800–1950.* Here was a signature icon of American art and not least, in its pulsing energy and frameless composition, an implicit forerunner of high Abstract Expressionism. Three years later Church's huge long-lost canvas *The Icebergs* (1861; fig. 21) was rediscovered and bought at auction for the Dallas Museum of Art for nearly $2.5 million, then an astounding record for an American painting. Shortly after, in 1980 it occupied a central place of attention in the mammoth exhibition at the National Gallery of Art, *American Light: The Luminist Movement, 1850–1875.* In reviewing that exhibition, the art critic for the *New York Times*, John Russell, drew a connection between the anxious turmoil of the Civil War period and the similar conflicts in the American state of mind during the Vietnam War era and its aftermath. Church was seen as a key figure expressing the ideology of his day, whose modern fortune could in part be tied to sympathetic contemporary sensibilities.

Church's artistic production found a natural extension in the conception and creation of Olana's landscape and building. In the design of his hilltop property and villa he had the participation of Calvert Vaux, who had recently collaborated with Frederick Law Olmsted in the planning of Central Park in New York City. This was followed in the 1870s by their work on Prospect Park in Brooklyn, developed about the same time as the plans for Olana, and curiously similar in their overall configuration and natural elements. The layouts of both are irregular parallelograms, which allowed for the calculated juxtaposition of water, fields, and forests. The major difference, of course, was Olana's organization around the gently rising hill, culminating in Church's Persian-style house at its crest. The contribution of Vaux's park-planning sensibility is evident in the careful separation and sequencing of distinct natural features and an ambulatory road system through the whole landscape experience.

For his part, Church brought his artistic vision, initially inspired and shaped by his teacher, Thomas Cole, and practiced by his fellow painters of the Hudson River School. Their landscapes usually featured a clear foreground, middle ground, and distance, often framed at either side by trees or rocky promontory. Similarly, Church transformed the original working farm into an artistic landscape by adding trees and digging a lake.

Around it all he introduced more than five miles of roadways: the two principal entrance roads as well as pleasure roads for viewing and roads to the farm areas. It was all romantic and picturesque, a three-dimensional realization of Hudson River landscape paintings. From the time one entered the property to the point of reaching the house at the summit of the hill, there were continually changing experiences of forest, views across the water, open fields, and shifting glimpses of the building itself in the distance, until one arrived at the dramatic polychrome structure, with all its playful surfaces and textures, irregular forms and silhouettes, its expression of individual personality and its lively relationship to its natural surroundings.

Nicholas Whitman, *Olana*, photograph, 2001

If the views *of* Olana revealed a significant and creative talent, the views *from* the building were equally artistic. Like its irregular massing of volumes, the ground plan is also asymmetrical, with a centralized entrance hall leading to adjacent rooms in all four quadrants. Especially noticeable is the variety of openings around the periphery on all levels: piazza, veranda, porch, and terraces. These help to break up the solid massing and integrate as transitional spaces the inside and outside. Just as important, the windows of different sizes and shapes, along with the columns supporting the several porches, all intentionally frame the views of both the immediate and distant landscape. Like Jefferson's Monticello, they look to all directions of the compass, surveying and unifying by implication the different horizons of the globe that Church had explored and painted. Contained within many of the windows facing south was the artificial lake, organizing the nearby landscape just as similar features in a Hudson River canvas do.

Farther off, the eye gazes over a wide stretch of the river itself, recorded in a number of oil sketches by the artist. From these openings Church could also capture the changing seasons, from spring blossoms to winter snow cover, and the visual drama of evening twilights. What he had so often painted during the 1850s and 1860s he now saw within his window pictures from Olana. As he wrote in a letter dated 22 July 1871 to his friend and patron William Henry Osborn, "The house will be a curiosity in architecture, but it will be convenient and the picture from each window will be really marvelous."

Nicholas Whitman, *Mexican and Native American Hats and Baskets in the Studio of Olana*, photograph, 2001

By the 1870s, when Church began to build Olana, tastes in American culture had shifted significantly. Major disruptions had occurred in the Civil War, Darwin's ideas had been published, and immigration and industrialization were having their effects. These and other factors overshadowed the optimistic, heroic vision painted by Church and his contemporaries. National union was in disarray and nature was now presented as cruel and haphazard, no longer an expression of biblical power and spiritual certainties. The market for canvases by Church, Albert Bierstadt, and their competitors shrank. In addition, Church had married in 1860, and several of their children were born over the following decade. He was ready to settle down to domestic life after a period of extensive travel both to the arctic north and the great mountain ranges of northern South America. Work on Olana was a natural retreat as well as a redirection of his creative energies.

The building and its grounds were themselves a work of art. But they also contained the artist's multiple collections, many accumulated on his travels abroad. Just as his architecture was an amalgam of East and West, Moorish and Gothic, so inside the furnishings and bric-a-brac reflected a far-ranging eclecticism. Preserved almost entirely intact are

Church's extensive art collections, including some 1,900 books and 5,700 photographic prints, 2,040 of which are devoted to subjects of travel, culture, or geology, and which provided rich sources of inspiration for his work. (The photography collection was recently discussed in depth by Thomas Weston Fels, and a sampling put on exhibition for the first time.) Church also acquired a number of paintings or copies after old masters and hung with them at Olana examples by his teacher, Thomas Cole, and friend Heade. Seen together, this material gives an invaluable picture of Church's personal vision and the broader artistic tastes of contemporary Victorian America.

Church was a prolific and successful artist and produced a large body of major finished canvases, which were often exhibited and sold to great acclaim in his lifetime. For these he also made an enormous quantity of preparatory drawings and oil sketches, many of a very high quality of draftsmanship and technical execution. They are additionally revealing as insights into the artist's working methods, his systematic close observations of nature, and scientific interests in specific types of geology or atmospheric and light effects. During his life he held on to most of his working drawings and sketches. When he died in 1900, Olana and its contents went to his son Louis Church. A decade and a half later Louis gave to the Cooper Union Museum (now Cooper-Hewitt) in New York more than two thousand sketches, the largest concentration of his father's work in one place. But remaining at Olana is the second largest grouping of about seven hundred pieces, including fifteen notebooks, five hundred drawings, and some eighty oils, both sketches and completed canvases. (Happily, this collection has been fully documented in a comprehensive scholarly two-volume catalogue by Gerald L. Carr.) They cover the full range of Church's career chronologically and thematically. It is the highlights from this personal collection that are now leaving the house for the first time to go out on exhibition.

Church's oil sketches were of two general types, those of quick impressions, rendering textures in rough, broad strokes of paint, and ones of meticulous detail and refined finish. Characteristic of the former are *Clouds over Olana* (August 1872; cat. no. 17), *Tropical Vines and Trees, Jamaica* (ca. May–July 1865; cat. no. 10), and *Study for "Under Niagara"* (ca. September 1858; cat. no. 6), while *Mexican Forest—a Composition* (1891; cat. no. 18) is a small finished canvas typical of his tighter Ruskinian mode. Living at Olana, Church loved the changing variety of the seasons, as is evident in his oil studies of apple blossoms on the property and the several sketches he did of the snow-covered fields leading down to the Hudson in one of his favorite views of the river from the windows and porches of the house.

We can get a good sense of his early style, developed under the influence of his mentor Thomas Cole, seen in such works as *The Catskill Creek* (ca. July–August 1845; cat. no. 2) as well as later in *Blueberry Hill, Vermont* (ca. October 1865; cat. no. 12).

The view of the Catskill mountain range depicted in the former repeats a composition favored often by Cole in a number of canvases from the same years. Like many Hudson River paintings of this period (for example, by Cropsey, John Frederick Kensett, Sanford Robinson Gifford, and Robert Duncanson), the scene is framed around a widening stream in the foreground. We reflect mentally and visually on the interchange between earth and sky, the water a symbolic eye akin to the literary construct of circularities in Henry David Thoreau's contemporary masterpiece, *Walden*. Later, after Church was married and settled in Olana, he almost constantly sketched views from the house, particularly to the south and west. Equally, he recorded views of the building at the summit of the hill, at the intersection between earth and sky, as in *Clouds over Olana*.

In the collection are two oil studies related to one of Church's first great masterpieces, *Niagara* (1857; fig. 15), a work of singular importance and influence. *Horseshoe Falls* (December 1856–January 1857; cat. no. 5) is a highly finished sketch for the Corcoran painting, noteworthy for its unusually extended horizontal format, employed to capture the panoramic grandeur of the site and to suggest the vast expansiveness of American geography. This emphatically lateral composition with an attenuated ratio of width to height of more than two to one would immediately have an impact on many of Church's Hudson River contemporaries, but it was especially taken up by his friend Heade in the latter's marsh scenes from the late 1850s through the rest of his life. By contrast, *Study for "Under Niagara"* was for another view executed subsequently, showing the drama of torrential water and mist below the falls, caught in much broader, richer brushstrokes. Here Church displays his highly innovative technique of differentiating his paint application for the various textures and specific physical characteristics of each element in his painting. For example, even in this simple sketch we can observe the changes in pigment handling from the sky to the rocks, the falls, and river water.

While Church's vision of Niagara belongs in a long tradition extending back to the beginning of the nineteenth century and the precedents of John Trumbull and John Vanderlyn, its spatial expansiveness and implied continental reach, as David Huntington has argued, especially captured the heroic, even imperial, sensibilities of America ascendant in the 1850s. Church was the most articulate artist of this time who extended that vision of America to a hemispheric one. If his *Niagara* looked to the west, he also in the mid-1850s began traveling and painting in the arctic north and in South America. In part, Church was caught up in the romance of science prevalent at midcentury. Beyond that, he saw the American image as a far-reaching and all-embracing vision of New World destiny. Interestingly, the earlier paintings from his first trips in the mid-1850s tended to be more serene, optimistic, and celebratory, as in *Mount Chimborazo at Sunset* (ca. July 1857; cat. no. 7) and *Study for "The Heart of the Andes"* (1858; cat. no. 8). The former, like its companion pictures of Cotopaxi, shows the volcanic peak at rest,

Frederic Edwin Church, *The Urn Tomb, Silk Tomb, and Corinthian Tomb, Petra*, March 1888 (detail; see cat. no. 13)

18

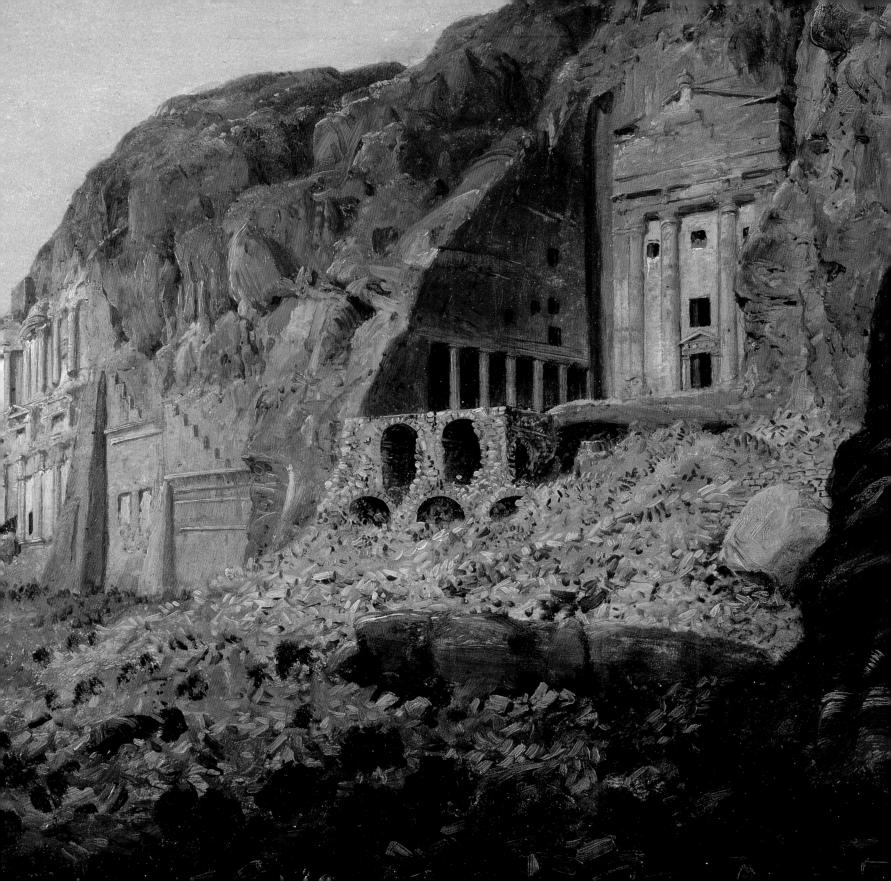

its near perfect geologic cone centered in the view, creating a solid classical form as heroic as contemporary Greek Revival architecture. The Andes sketch, of course, is a finished study for the great final canvas of 1859 now in the Metropolitan Museum of Art, the culminating picture of Church's biblical interpretations of American hemispheric geography. As Steven Jay Gould has pointed out, the artist subsequently sent it to Europe for the venerable German philosopher and historian Alexander von Humboldt to see, but this natural scientist, who had been such an important inspiration for Church, died before the painting reached him. That same year Charles Darwin published his fateful treatise *On the Origin of Species*, which directly assaulted the painter's unified and spiritual vision by arguing that nature was harsh and unpredictable. Soon after, the trauma of the American Civil War began, and the American landscape became a scene of disunion and bloodshed. We know Church reflected these dramatic changes in his later South American paintings, most vividly in Cotopaxi exploding in 1862.

The other major pictorial theme that preoccupied Church during the decade of the 1850s into the 1860s was that of sunset and twilight. There are numerous examples in the collection at Olana, and several are included here. They, too, tend to have been more tranquil and subdued when he began such studies in the late 1840s and early 1850s. We know in part they were made possible by the new availability at the time of the intense cadmium pigments in reds and yellows. Church almost immediately used them to record the dazzling optical phenomena he experienced in his New England travels, especially to the Maine coast throughout the 1850s. By the later part of the decade we can observe his combinations of these hot colors becoming more brilliant and fiery, even approaching lurid in their visual drama. *Twilight, a Sketch* (1858; cat. no. 4) in particular anticipates his culminating masterpiece, *Twilight in the Wilderness* (1860; fig. 14). Painted on the eve of the Civil War and at the moment of Darwin's publication, it presents a scene of explosive intensity and tension, a visual premonition of the fiery trial about to grip the nation. Some of the small studies executed in preceding years were based

Nicholas Whitman, *Middle Eastern Metalwork, Painted Mexican Bowl and "Sunset, Jamaica," in the East Parlor of Olana*, photograph, 2001

on observations Church made at Mount Desert in Maine, but he gradually transformed them into his summary wilderness painting.

As Church's work moved from the 1850s into the 1860s, we might see his subject matter, like that of Gifford and other contemporaries, as responding to both flight and pursuit. That is, on the one hand, American artists sought out ever distant frontiers to paint, partly for the exoticism and partly because nearer terrains were no longer pure wilderness. On the other hand, with the disruptions of war and its aftermath, Church seems to have turned to the Old World for the solace and inspiration of ancient culture and religion, leaving the trauma at home behind. If Darwin had undermined the spiritual determinism in the American landscape, Church could pursue the religious experience of biblical lands in the Near East and early Western civilization in Greece.

In February 1868 he visited Petra in Palestine (modern-day Jordan), where he painted *The Urn Tomb, Silk Tomb, and Corinthian Tomb, Petra* (March 1868; cat. no. 13) and made several sketches of El Khasné, which he would use for a large canvas completed six years later at Olana. *El Khasné, Petra* (by April 1874; cat. no. 1) is the most impressive canvas in the artist's collection, the only large-size work that he integrated into the original decor of the house; the picture occupies pride of place in its interior. Its vertical format relatively unusual for Church, the composition depicts the rock-cut temple viewed through a darkly shadowed opening in the cliffs. In many aspects it perfectly matches the ambience of Olana: as an image joining architecture and landscape, as a view through a framed opening, and as a subject focusing on ornamental carving with rich coloring. Regarding the latter, Church himself referred in his journals to the "gorgeous" veins and "splendid colors in the rocks." He made a point of presenting the finished painting to his wife, Isabel, and installed it over the fireplace in the Sitting Room. As Gerald Carr has noted, its pinkish tonalities match the decorative marble below and generally complement the Near Eastern motifs and decorations throughout the room. The colors also have visual companions in the nearby oils of Cole and Heade and in the real sunsets to be seen across the river and over the Catskill Mountains. Moreover, the pictorial opening through the cleft in the rocks has echoes around the room and the rest of the house, in the various Middle Eastern arches, niches, window recesses, hallways, and other enclosures. Along with the other paintings hanging nearby on the walls of Olana, this work offers rich insights into Church's mature artistic and domestic life, and their wider exhibition is to be warmly welcomed.

Overleaf:
Frederic Edwin Church, *Königssee, Germany,* July 1868 (detail; see fig. 33)

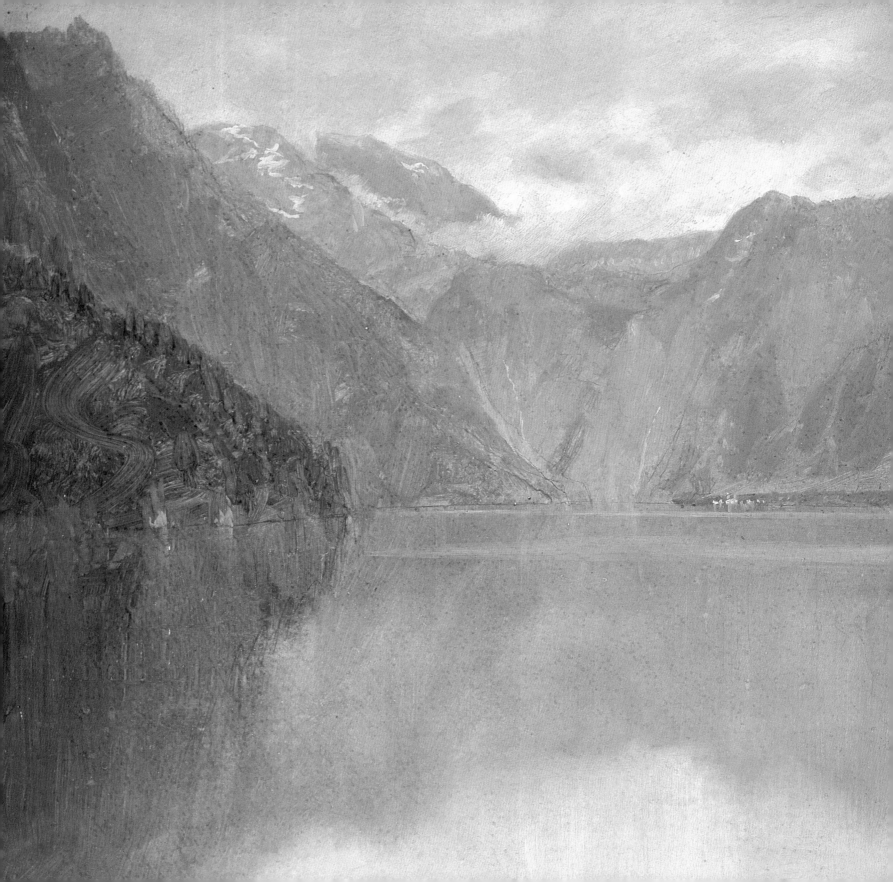

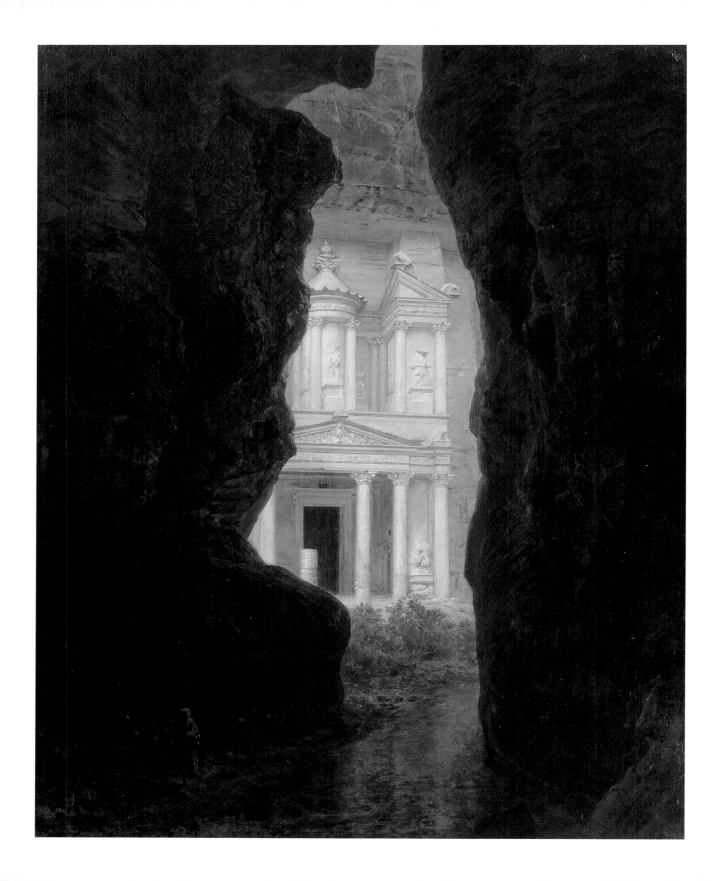

Kevin J. Avery

Treasures from Olana

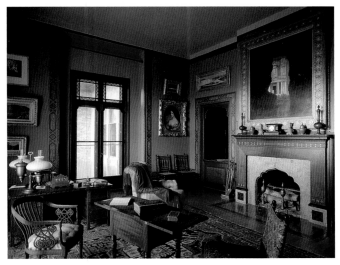

Fig. 1. Kurt Dolnier, *Sitting Room at Olana, with "El Khasné, Petra" over the Fireplace*, photograph, 1997, © Kurt Dolnier

When visitors to the Olana State Historic Site take the tour of the stately, fanciful house of the artist Frederic Edwin Church (1826–1900) perched high on the Sienghenbergh over the Hudson River, they may catch an odd whiff of the familiar in the Sitting Room (fig. 1). Housed in an orientalizing gilded frame above the ogee-shaped fireplace—itself an echo of porticoes, archways, and window openings thoughout the home—is a painting of a glowing classical facade glimpsed through a narrow rock cavern or cleft (cat. no. 1). Even before the docent identifies the painting, the sight of it may evoke the impression, not of the two shadowy Bedouins guarding the passage, but of the silhouettes of four horses galloping into it. The visitor may then smile, recalling the lead horse being ridden by Harrison Ford, as the adventuring archaeologist Indiana Jones.

Stephen Spielberg's 1989 movie, *Indiana Jones and the Last Crusade*, the last of the widely popular film trilogy, cast its climactic scenes at the rock temple (or tomb) at El Khasné, Petra, in Jordan. There, more than 120 years earlier, Church made sketches for the most striking and significant picture of the many that he framed for his home, and which forms the centerpiece of this exhibition. For the director and the artist, the attractions of the site were virtually identical: the visual drama of the sun-struck facade throwing what seems its own light into the gloomy stone passage framing it. But, more to the point, and perhaps due to the dazzling aspect projected by El Khasné, the tradition of the place, not as the tomb that it actually was, but as a treasury, which its splendid yet secreted aspect evokes and its Arabic name actually means, compelled both Spielberg and Church.[1] In the film, El Khasné shelters no less than the Holy Grail, the legendary chalice used by Jesus at the Last Supper. The painting, installed by Church over the fireplace as a gift to Isabel, his wife, is a deliberate metaphor of their house.[2]

Cat. no. 1. Frederic Edwin Church, *El Khasné, Petra*, by April 1874, oil on canvas, 60½ × 50¼ in., OL.1981.10

Fig. 2. Nicholas Whitman, *Olana, Southeast Corner*, photograph, 2004

Fig. 3. Kurt Dolnier, *Court Hall at Olana*, photograph, 1997, © Kurt Dolnier

Its status is only underscored by the location of the image, with its little creek flowing through the cleft seemingly from the foot of the temple, facing a south window that reveals the Hudson River gliding beyond the base of the hill on which Olana stands. About 1880 the couple gave the house its name, inspired by a reference they found to a "fortress" or "treasury-storehouse" in ancient Persia.[3]

To visit Olana today is to gather an indelible sense both of the fortress and the treasury that Church intended. Its eminence above the Hudson River Valley scarcely prepares one, as one circles the house's southeast corner, for the opposing sensations of skyward thrust of its towers and groaning weight where its stony foundation meets the bare ground (fig. 2). Don't let the building's surface decoration or the leisurely look of the window awnings in summer fool you. Church often called Olana his castle, and for good reason.[4]

The decorative arabesques that lighten the mass of the exterior also intimate the Arabian Nights theater, subtly faded by the years, of the interior. At first sight the Court Hall, the heart of the house (fig. 3), evokes nothing so much as a silent film set, minus a turbaned Douglas Fairbanks Sr. bounding down the stairs. That may be because it was the silent era of the 1910s and 1920s that tolled the death knell of the orient-flavored, concertedly eclectic age of Aestheticism that Church, with an earnestness we probably can never quite comprehend, helped establish in America with Olana in the 1870s.

The taste was annihilated by the world wars and the modernism that went with them. But those events and trends of the twentieth century bypassed Olana like the river below. Long before his death, in 1900, Church made one of his sons, Louis (fig. 4), the professional caretaker of his property. The artist evidently instilled in his son an abiding sense of obligation to his father's creation. After assuming possession of the property, Louis changed little inside or outside, nor did his wife, Sally (fig. 5), after his death in 1943. One observer claimed that Louis regarded Olana as a memorial to his father. Sally is said to have foreseen Olana as a public park, and long before her death in 1964 there were calls for its preservation, which was formalized by the State of New York just two years later.[5] By virtue of artistic legacy, family loyalty, and, no doubt, rural isolation, one of the marvels of Aestheticism has survived. Yet, due to its very rarity, we find that, in the words of the novelist L. P. Hartley, "The past is a foreign country: they do things differently there."[6]

Thus we still witness wall color schemes of understated ochers, roses, mauves, and sere blues couched in warm wood moldings, staircases, columns, cabinets, and banisters, yet all lent a faint, glittering restlessness by the patterned rugs and tapestries, the solar glow of the amber-filtered window on the stair landing, the gilt picture frames, the iridescent accents in the stenciling of arches and door frames (and, for that matter, in the plumage of the stuffed peacock and resplendent quetzal mounted on the first stair landing), and—everywhere—the glinting and glossy bric-a-brac: bronze, brass, iron or steel birds, a Buddha, candelabra, curtain rods, platters, planters, trays, urns, censers, shields, swords, and lances; ceramic vases, pitchers, jars, dishes, cups, and saucers. No horizontal surface in the house is clear of these tchotchkes, including the floor: it is the vacant chairs in each room that assure one that people lived here, though the furniture's own busy surface decoration challenges even that assumption. From the first Church must have intended that the house would be the repository and museum of his worldly experience and taste,[7] with his compendious library supplying him privately the content of labels, which the visitor often could wish for, to particularize such a plethora of the exotic. Indeed, the primary impression of Olana's variety seems not to reflect an amassing over time; the accessories suggest that Church accumulated en masse expressly for the home that he only began building in earnest on his return from Europe and the Middle East in 1869. Following him back to Hudson were fifteen crates of what the artist described (and his home reveals) as a "medley in a box . . . rags, armour, stuffs, curiosities . . . old Clothes (Turkish), stones from a house in Damascus, Arab spears—beads from Jerusalem—stones from Petra and 10,000 other things" that he had collected abroad.[8]

The key word above is "curiosities," or its singular, less with reference to the exotic objects Church imported than to the omnivorous visual and intellectual appetite reflected in the paintings that made him famous and helped to make him rich. The majority of

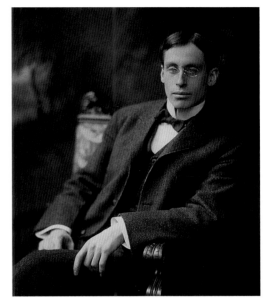

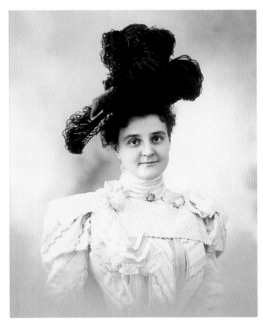

Fig. 4. Photographer unknown, *Louis Palmer Church*, n.d., platinum print, 8⅜ × 6⁵⁄₁₆ in., OL.1982.1369

Fig. 5. J. W. Floyd, *Sally Good Church*, ca. 1891–93, albumen print, 6½ × 4⁵⁄₁₆ in., OL.1990.62

Fig. 6. *Frederic Edwin Church*, ca. 1860, photograph, 3⅞ × 2⅜ in., OL.1986.628

Fig. 7. Attributed to Mathew Brady, *Thomas Cole*, ca. 1845, albumen print, 4⅛ × 2½ in., OL.1982.1294

those are now in museums. But, besides *El Khasné, Petra* (cat. no. 1) and a few others, most of the paintings at Olana—and those sampled in this exhibition—are small. The pictures in the house become conspicuous only as the decor, with time, begins to release the visitor's attention and allows one to look at the paintings. Products of Western traditions of pictorial illusionism, they are darkish, concentrated perceptual zones of their own, however decorative their frames may be, culturally antithetical to the abstract Eastern aesthetic that Church embraced in the 1870s. Indeed, many of those now hanging or stored at Olana date from before the house was built and represent the artist's numerous probes into the New World that preceded his only trip to the Old. If anything links the paintings aesthetically to the house, besides the common authorship of image and domicile, it is the taste for spectacle—albeit natural spectacle—that so many of them evince. Even if, at Olana, the paintings address our consciousness almost secondarily, they are the house's truest treasures. Their subjects were the compulsive artist's original curiosities, the vivid wresting with his hands of the earthly and celestial objects of his eye, mind, and imagination.

The best visual suggestion of these three faculties is a photograph of Church taken about 1860 (fig. 6), after he cultivated his muttonchops but, gratefully, before a thick mustache cloaked the youthful openness of his face, with its high forehead and calm, wondrous gaze—as much looking for something as apprehending it. Contrast that with the starry-eyed certitude of Thomas Cole, father of the Hudson River School of landscape painters and Church's teacher, in a photograph made a few years before his death in 1848 (fig. 7). Cole really does appear to see the unearthly, ideal realm that so inspired the content, forms, and execution of his heroic landscapes (fig. 8), whereas Church seems, if anything, transfixed by what-in-the-world-is-it, and even intrigued by what he might make of it. The unknown photographer of this portrait must have orchestrated these traits. By the time the picture was taken, the artist had already painted several of his best and best-known works. One of them, *The Heart of the Andes* (see fig. 19), is the largest and most renowned that he ever produced.

To the artist's father we may ascribe the worldly expectation embodied in Olana, as well as the work ethic, perhaps even the manual dexterity, to achieve it. Joseph Church (fig. 9) of Hartford, Connecticut, was a jeweler, silversmith, and insurance adjuster whose steady and rising local accomplishment earned him wealth sufficient to subsidize his famous and prospering son when Frederic still needed money to buy and enlarge the property on which Olana would be built.[9] The artist's earliest biographer reports that, as a young boy, Church used his father's tools to build a clock and a small steam engine and professed a future as a practical inventor.[10] But his intelligence and dexterity really lay elsewhere: during his earliest schooling in Hartford, Church's teachers discovered in him an aptitude for drawing so exceptional that he was "placed on a chair on the [classroom]

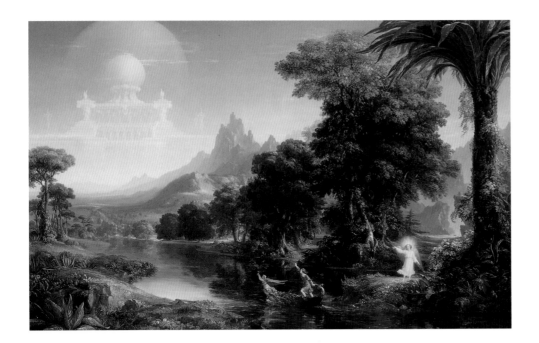

platform and left there to make drawings that would interest others. He remembered some people coming expressly to look at the drawings he had made."[11] The boy Church combined with this talent a rapture for the most transient of phenomena—"the evanescent qualities of the atmosphere, the luminous depths of the sky, the infinite tone gradations in the clouds"—and a compulsion to "collect" them: "It is related that he would often return from his ramblings in the country with his hat full of pencil sketches of the clouds."[12]

Church's innate powers were not cultured in a vacuum. Several artists worked in Hartford, including Benjamin Coe, who in 1842 authored the first of several drawing books that earned him a role in the blossoming art instruction movement in America, and Alexander H. Emmons, a landscape and portrait painter. In 1842–43 Church studied with both and formed fast friendships with a few contemporaries in the city who aspired to the more traditional and economically reliable genre of portraiture. The annual agricultural fair in Hartford offered a venue for artists' works, including Church's earliest exhibited drawings and paintings.[13] But above all, perhaps, near Hartford lived one of the nation's leading art collectors, Daniel Wadsworth, who would found in the city America's first public art museum, the Atheneum, in 1844, when Church was eighteen. In the same year, Joseph Church prevailed on Wadsworth to intercede on his son's behalf with Cole —whose landscapes Wadsworth had avidly collected since the artist's earliest days in New York—to take Frederic as a pupil in his studio at Catskill, New York, in the shadow of the mountains that Cole and his Hudson River School descendants made famous in

Fig. 8. Thomas Cole, *Voyage of Life: Youth*, 1840, oil on canvas, 52½ × 78½ in., Munson-Williams-Proctor Arts Institute, Museum of Art, Utica, New York, 55.106

Fig. 9. Charles Loring Elliott, *Joseph Church*, 1865, oil on canvas, 34½ × 27⅜ in., OL.1981.5

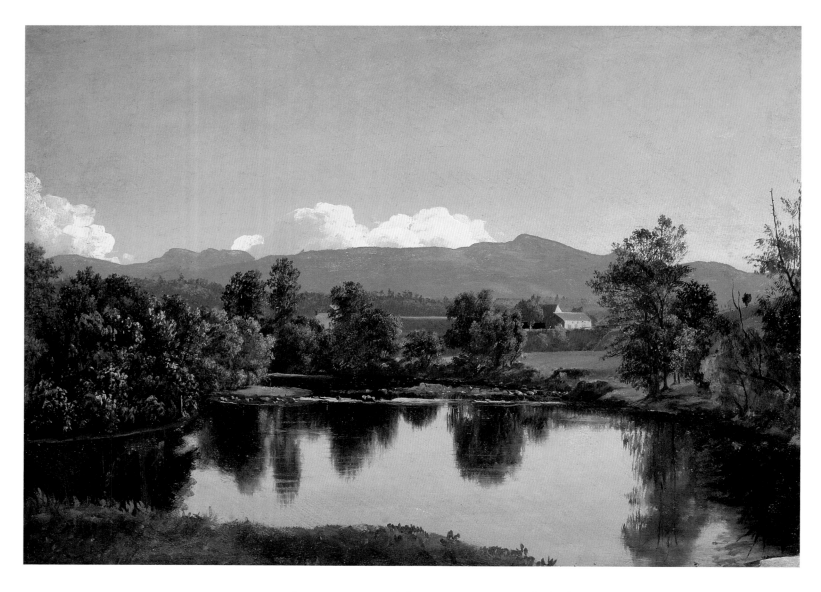

Cat. no. 2. Frederic Edwin Church, *The Catskill
Creek*, ca. July–August 1845, oil on beveled
pine panel, 11⅞ × 16 in., OL.1980.1873

their paintings, and the permanent view of which Church would command from Olana.
It is a measure of Cole's sense of obligation to Wadsworth that he accepted Church, the
first of only three students to enjoy the privilege during the master's few remaining years.[14]

 In his letter introducing himself to Cole, Church confided: "I have never before this
spring attempted to paint from nature, but of all employments (as far as I have had expe-
rience) I think that the most delightful."[15] At Catskill Cole promoted no concerted course
or method except to "paint things as you see them."[16] After all, he quickly recognized,
according to Louis Legrand Noble, Cole's earliest biographer and devoted friend to both
artists, that the youth "possessed the finest eye for drawing in the world."[17] Far more

important, he made Church and his other students his "friends as well as pupils."[18] They dined with Cole and his family and became the companions of his sketching tours west to the Catskills and east to the Berkshires of Massachusetts. Just a month after arriving at Catskill, Church accompanied Cole on a trip to the vicinity of the Catskill Mountain House, the famed hotel resort 2,300 feet above the Hudson River Valley, where they roomed for several days.[19] Catskill subjects formed the majority of Church's drawings and paintings during his tutelage with Cole and a large proportion of his work that remains at Olana. Those include the at-once startling and prosaic panel painting, probably executed in the summer of 1845, of a prospect that Cole and his colleague Asher B. Durand had made classic: the view over the Catskill Creek to the dolphin-back profile of Kaaterskill High Peak, which dominates the eastern peaks in the range (cat. no. 2).[20]

The view was significant to artists not simply for the irregular line of the mountains that animate the background or for the water mirroring the sky in the middle distance—both standard properties of the classical landscape—but because the creek issued from Kaaterskill Clove, between High Peak and South Mountain, where the Mountain House (then barely visible from both artists' point of view but not picked out in either picture) beckoned the artists' patrons. When Cole rendered the prospect in his best-known version of 1837 (fig. 10), the year after he moved to Catskill, he cast it in a longing of either reminiscence or expectation, with the golden late afternoon light in which he bathed it abetted by the shaggy elms that umbrella the foreground and screen the sun's glare and by a tableau of mother and child on the riverbank. Church undoubtedly knew at least one of his master's images of the scene, and it is not hard to imagine him literally assigned by Cole to essay it. In parking himself before the view, Church seems to have moved just a little to the right (west) of Cole's usual vantage point, as if to improve a found composition (note the echo of the contour of the mountain range in the line of the near riverbank) rather than to imitate that of his teacher. That said, the result seems precisely to heed Cole's advice to "paint things as you see them." To do so, the young artist may well have needed the time afforded by broad daylight to study and transcribe all the middle-distance foliage, even in such small scale. The red ground or underpaint that reflects Cole's method warms the dominant greens and blues in a way very reminiscent

Fig. 10. Thomas Cole, *View on the Catskill, Early Autumn*, 1837, oil on canvas, 39 × 63 in., The Metropolitan Museum of Art, Gift in memory of Jonathan Sturges, by his children, 1895. (95.13.3), Photograph © 2001 The Metropolitan Museum of Art

Fig. 11. Frederic Edwin Church, *New England Scenery*, 1851, oil on canvas, 36 × 53 in., George Walter Vincent Smith Art Museum, Springfield, MA, George Walter Vincent Smith Collection

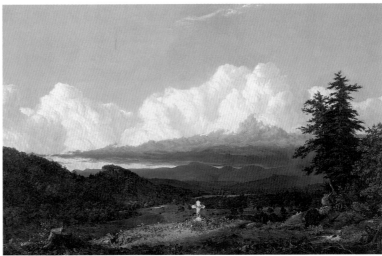

Fig. 12. Frederic Edwin Church, *West Rock,
New Haven*, 1849, oil on canvas, 27⅛ × 40⅛ in.,
New Britain Museum of American Art, John
Butler Talcott Fund, Photo: Michael Agee

Fig. 13. Frederic Edwin Church, *To the Memory
of Cole*, 1848, oil on canvas, 32 × 49 in., private
collection

of the master's paintings, and the mountainous cumulous clouds peeking from behind
the ridges recall Cole's taste for the celestial sublime. But compared with any view
by Cole, Church's seems photographed, not contemplated. He is more intent on get-
ting all of the component parts of the landscape accurately than on interpreting the
spirit of the scene or imposing one on it, as Cole's painting does. The work, after all,
is only a small, fastidious sketch of a view that had been aggrandized in the works
of his master.

Still, despite the informal nature of the painting, it is surprisingly prescient of some
of Church's major pictures of the next decade, indeed, of a whole category of his early
output: the domestic North American landscape. One of the most notable of these,
New England Scenery (1851; fig. 11), synthesizes natural and bucolic vignettes from widely
disparate locales in the Northeast, binding them all in a Colean glow, yet not forgetting
the homeliness exhibited in *Catskill Creek*, even as that picture only hints at the grandeur
of the later painting. Closer to the dispassionate perception of this sketch is *West Rock,
New Haven* (1849; fig. 12), a sizable and ambitious painting, to be sure, and striking for
its elaborate cloudscape, but marked by a cooler and harder precision. Perhaps most
significantly—and poignantly—Church returned to this approximate vista just three
years later in *To the Memory of Cole* (1848; fig. 13), a four-foot landscape that explicitly
mourns his departed master. Cole had died from pulmonary disease in February 1848,
just two years after the pupil moved to New York City (after a brief stint in Hartford)
to start his artistic career. Evergreen trees, associated with immortality, now bound the
prospect at right; dark clouds, alleviated by angelic cumuli above them, lay a pall over
the Catskill ridge; and a marble cross, wreathed in red blossoms, occupies the creek bank
left empty in the sketch.

If the clouds in these pictures assume a mass comparable to the mountains they bloom above or the effulgent trees they often echo, in the succeeding decade Church, having grasped the apparent tangibles of earth and sky, renewed his pursuit of those "evanescent qualities of the atmosphere, the luminous depths of the sky" that had entranced him on his boyhood walks. Following his second visit to Vermont in the summer of 1849 and further stimulated by several trips to Maine in the next decade, Church introduced vivid sunsets and twilights into many of his North American landscapes, much as if their more challenging ephemeral effects were catching up with the terrestrial forms that he had already mastered.[21] For every finished painting there seem to be several oil sketches or studies, including two (cat. nos. 3, 4) in the Olana collection, that appear related in respectively lesser and greater degree to Church's crepuscular masterpiece, *Twilight in the Wilderness* (1860; fig. 14). One is undated, but the resemblance of its planar terrain to the region surrounding Mount Katahdin probably locates it during or just after one of Church's trips to Maine in 1852 or 1856.[22] Something rare had caught the artist's attention (which happened constantly, yet never became routine): the tint of the twilit horizon divided evenly into contiguous pink and yellow passages—perhaps

Cat. no. 3. Frederic Edwin Church, *Sunset*, ca. 1856–65, oil on paper mounted on ragboard and panel, 11⅝ × 18¼ in., OL.1980.1633

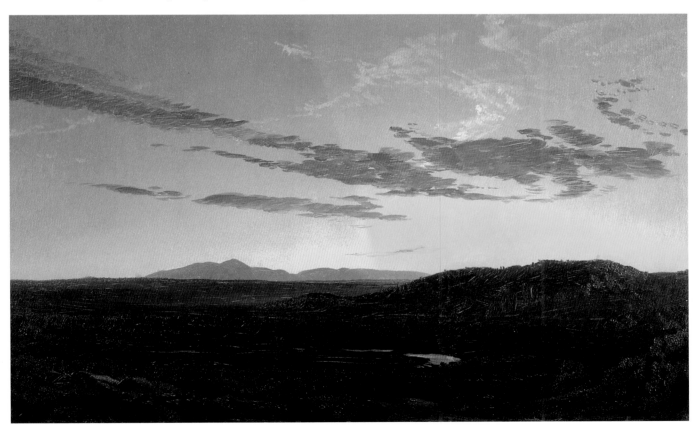

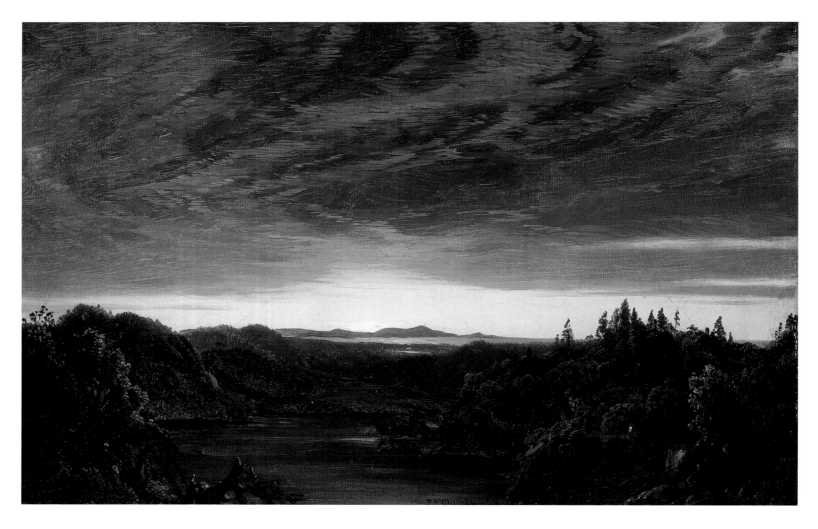

Cat. no. 4. Frederic Edwin Church, *Twilight, a Sketch*, 1858, oil on canvas, 8¼ × 12¼ in., OL.1981.8

caused by filtering mists or clouds sitting out of sight beyond the terrain at right—like pigments juxtaposed on a divine palette. The color zones are bridged by stratus clouds tinged orange by the submerged sun's fires, while higher wisps of cirrus escape ignition, both types animating the otherwise slumbering landscape. Church may not have seized this impression directly on the spot, but, if not, it was recorded while still hot in his recollection.

The other picture (cat. no. 4), dated two years after the artist's second visit to Katahdin, is an exquisite study for *Twilight in the Wilderness* that Church exhibited as a "sketch" at the National Academy of Design in 1859, even as his ten-foot *Heart of the Andes* (see fig. 19) was drawing five hundred paying spectators a day at the Tenth Street Studio Building in New York. In this miniature presentment of the five-foot *Twilight in the Wilderness*, the high, hovering point of view of the earlier sketch has given way to

an earthbound vantage that orients the viewer more concertedly to the sky, now fully
enflamed with columns of sun-charged clouds fanning outward from the horizon, where
a searing band of yellow sky sets off a violet mountain. Aside from size, the painting of
1860 differs chiefly in its wider format, the upcurving contour
of the land advancing toward the viewer at either side (thus
suppressing the focal mountain at center), and the taller fore-
ground trees silhouetted against the sky.

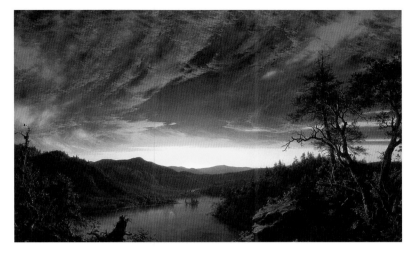

 In Church's sunsets, as in his celestial effects in general,
inspiration met fascination, faith informed perception. His sen-
suous nature was seasoned with the liberal Calvinist inculcation
of his Hartford upbringing to imbue his scrutiny of the natural
world with providential import.[23] This dualism is already obvi-
ous in *To the Memory of Cole* (fig. 13). The master's religious allego-
ries only would have fostered the young painter's sympathies,
even long after the explicit religious iconography of Cole's alle-
gories was left behind by Church and his contemporaries of the
second-generation Hudson River School. But both clerical and
aesthetic commentators of Church's early adulthood promoted
the divine suggestiveness of the landscape (which in turn helped
sanction the imperialist impulses of the nineteenth-century

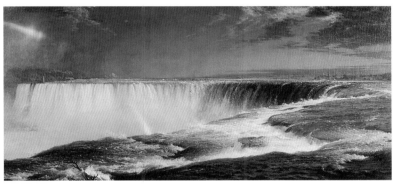

age of exploration in which Church participated).[24] Men of the
Word preached the Design to be found in God's Creation, while
the righteous British critic John Ruskin, whose *Modern Painters*
was read by every Anglo-American art lover, pointed to "cre-
puscular glories" as betokening "[God's] own immediate pres-
ence as visiting, judging, and blessing us."[25] Indeed, it is just
what Ruskin suggests in the nature of twilights—"that immedi-
ate presence," there and gone again, their gorgeous but apparitional character—that
appealed at once to Church's curiosity and piety. To him, ultimately, a sunset image
in his house may have had something of the votive power of a gold monstrance or
crucifix in a church.

 When, with *Twilight in the Wilderness*, Church cemented his reputation as the
premier American painter of aerial phenomena, he was already the premier painter
of earthly facts, including water. If any date marks that attainment, it is 1857, the
year he showed his seven-and-a-half-foot *Niagara* (fig. 15) by itself in a commercial
gallery in New York. Church became not merely a public artist but a national, even
international, one. The exhibition traveled to several cities both at home and in Great
Britain. Its appeal lay precisely, in part, in Niagara's identity as both a natural and a

Fig. 14. Frederic Edwin Church, *Twilight in
the Wilderness*, 1860, oil on canvas, 40 × 64 in.,
© The Cleveland Museum of Art, Mr. and
Mrs. William H. Marlatt Fund, 1965.233

Fig. 15. Frederic Edwin Church, *Niagara*, 1857,
oil on canvas, 42½ × 90½ in., Corcoran Gallery
of Art, Washington, D.C., Museum Purchase,
Gallery Fund, 76.15

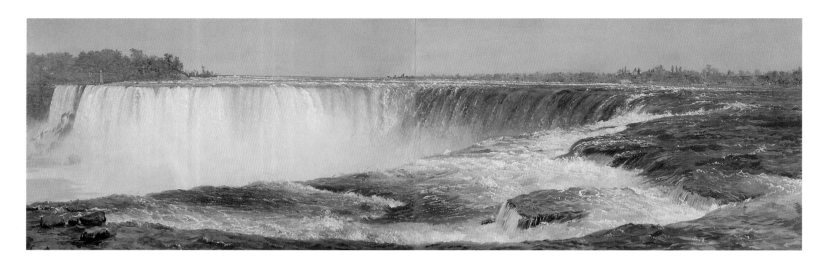

Cat. no. 5. Frederic Edwin Church, *Horseshoe Falls*, December 1856–January 1857, oil on two pieces of paper, joined together, mounted on canvas, 11½ × 35⅝ in., OL.1981.15

national landmark, perhaps *the* national landmark, and one especially dear to his then fellow New Yorkers, whose state Niagara bordered.[26] But Church's ambition to portray it would have signified nothing if his treatment were not exceptional; Niagara Falls had been represented countless times before, including in a sixteen-hundred-foot-long moving panorama exhibited in the city in 1853.[27] Church's singular conception began in his refusal to represent the portrait of the Canadian, or Horseshoe, Falls full-face, the view resorted to by most artists before him. At least three preparatory images, including the ultimate oil study in this exhibition (cat. no. 5), which Church later displayed at Olana, disclose that even in the formative stage Church conceived his image as not only or even principally about the waterfall itself but about the oceanic Niagara River, its irresistible thrust—as well as the falls' gravitational pull—and the dreadful brink where the two forces meet. Or it might be said that Church here perceived the power of the cascade not in its drop—after all, Niagara is only about 167 feet high and we can scarcely see its bottom in his pictures—but in the expectation of it. The idea led him to the edge of the Canadian shore from where he imagined his view and, more important, chose not to depict the riverbank itself as a secure foreground, conceptually depositing the viewer on the rushing water. The uncanny rendering of that, in all its furious gush and freshet, spume and spray, he had rehearsed not only in several pencil and oil sketches (fig. 16) of the rapids above and below the falls but in drawings and paintings of the Atlantic surf in Maine and Canada in previous years.[28] The highly articulated oil study at Olana (cat. no. 5), painted on two sheets of paper, advanced beyond an earlier one (private collection) by excluding a distant view of the American falls downriver, thus concentrating on the acutely foreshortened curve of the Canadian Falls.[29] A few critical changes occurred in the composition of the large painting. The height of the image was increased to allow for some aerial relief, but the sky was populated with darkish

clouds whose tapering ends seem subject to the same inexorable vacuum as the water; the rainbow that the artist added to the painting completes this elemental stoop; the distant terrain at either side figures even more marginally than in the study. And the line of the immediate foreground plane of water was adjusted to parallel the near rim of the cascade, reinforcing the leftward thrust. Finally, the rocks at the lower left of the study become, in the painting, a waterborne tree branch, headed for the gulf. *Niagara* may not be Church's best painting, but it is surely his shrewdest, disguising its essential suggestiveness with dazzling literalism. The public hailed the sorcery without necessarily grasping its source. For them the picture hypnotized like the landmark itself: *"Niagara, with the roar left out!"*[30]

It is a mark of the persistent charm that Niagara held for Church that he returned to it twice in major pictures, the second time in what became two of the most compulsive working campaigns of his life. The "contact" with the cataract from the Canadian shore in 1856 had not been enough for the artist. As the first painting was completing its tour of Britain in August and September 1858, Church revisited Niagara and chartered the tourist boat we still know as *The Maid of the Mist* to approach the roiling foot of the Canadian Falls, in his own words, "to try the experiment of keeping the steamer to the utmost limit in the great gulph . . . —for as long [a] time as I needed to make a sketch—The experiment had never been tried—but succeeded well—we remained tossing in the surging foam for forty minutes until I succeeded in making a rough sketch in oil."[31]

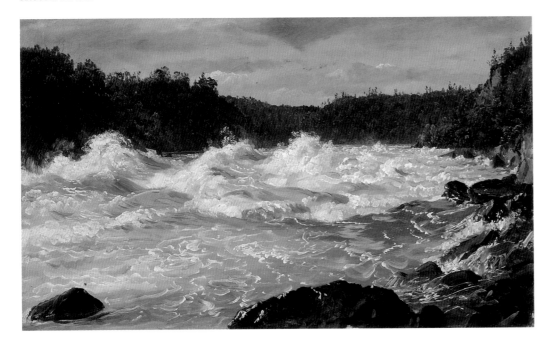

Fig. 16. Frederic Edwin Church, *Niagara River Gorge,* September 1856, brush and oil on paperboard, 10⅝ × 16 in., Cooper-Hewitt, National Design Museum, Smithsonian Institution, Gift of Louis P. Church, 1917-4-168, Photo: Scott Hyde

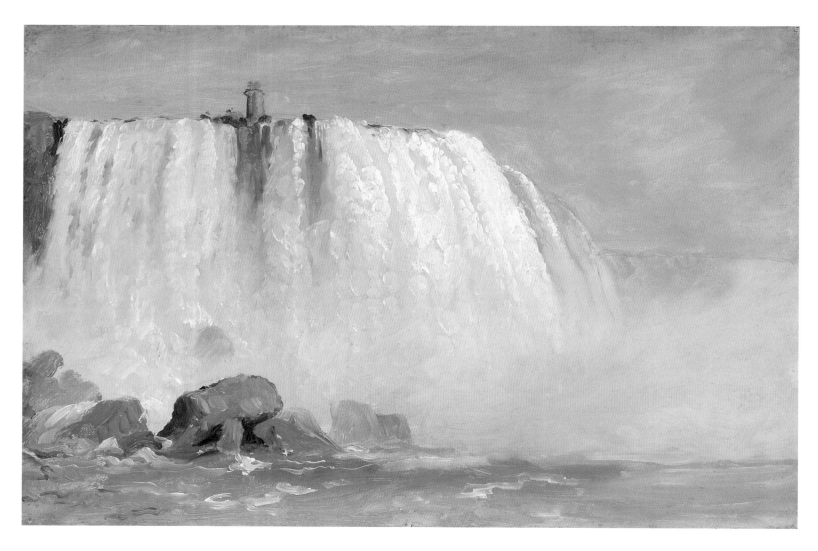

Cat. no. 6. Frederic Edwin Church, *Study for "Under Niagara,"* ca. September 1858, oil on paper mounted on canvas, 11¾ × 17½ in., OL.1981.51

Catalogue number 6 is almost without doubt the declared product of his rocking "experiment." Taking the artist's words at face value, that it represents less than an hour of his labor, we witness the speed and confidence with which he wielded oil pigments even in untoward conditions, translating the propulsive energy of the cascade into the agitation of his hand guiding the white-loaded brush from the top of each fold composing the watery curtain. The rocks and current below look little more solid than the kinetic falls, but they could be firmed up from other sources. What he needed from that day's close encounter was the tidal launching of the water from above and the shattered, rebounding mist—perhaps managed with a few deft swipes of a rag—to communicate the sheer force of the cascade, as much leaping as falling.

And what Church transported directly from the experience to the finished work was a comparable—and unusual—immediacy of process. Today we know the six-foot painting, *Under Niagara* (1862; unlocated), only from an excellent chromolithograph (fig. 17); but eyewitness reports reveal that Church painted it within a single day.[32] Granted, the forms to be represented were large and simple and the palette limited. Even so, as the chromolithograph shows, he did not merely amplify the on-site sketch but built up the contour of the falls' edge to a peak and strengthened individual funnels of the cascade to emphasize better the muscular mountain of water, shaggy as a wild horse's

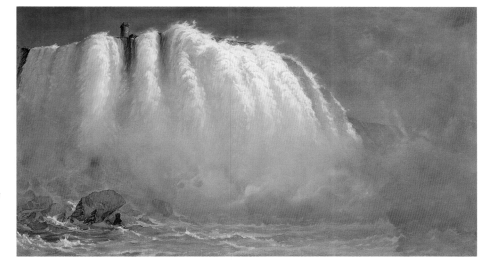

mane, being hurled and dumped virtually on the spectator. To magnify the awesome effect, Church reduced the scale of the boulders at lower left and subtly parenthesized the image at right with the rising spray, spectral vestiges of the descending volumes of foam. Given Church's concentrated working stint (and judging from the chromolithograph), we can hardly doubt that the energy with which he dashed off the oil sketch was, in a measure, extended to *Under Niagara*.

None of the works admired so far reflects the subject matter with which Church became principally identified in his time and for which his reputation—like Olana, obscure for the better part of a century—was revived after World War II. The artist's most acclaimed paintings were of equatorial South America. No doubt those are impressive, but they may puzzle the modern viewer: what should have attracted a master of sublime national scenery to the sweaty jungles and freezing summits of Colombia and Ecuador, and why should his audience have clamored to see the outsized results? In something of the way we can never quite recover the currency of the Aesthetic fashion that Olana reflects, we cannot now quite "get" the popularity in Church's time of Alexander von Humboldt (fig. 18), the German naturalist whose books, widely translated, were read by virtually every inquiring Western person.[33] Humboldt's multivolume *Cosmos* (English translation, 1849–59) and, with Aimé Bonpland, *Personal Narrative of Travels to the Equinoctial Regions of the New Continent, during the years, 1799–1804* (English translations, 1818 and 1852), published probably in the hundred of thousands, seemed to describe everything natural in the wide world of the nineteenth century and to assign each one a place in the grand order of things. The "laboratory" of Humboldt's observations was Latin America, which he explored for five years at the turn of the nineteenth century. Especially in the equatorial Andes, Humboldt perceived an ideal encapsulation

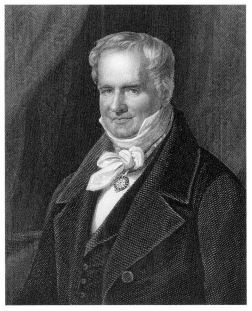

Fig. 17. Frederic Edwin Church, *Under Niagara*, 1862–63, chromolithograph retouched with oil, 17⅛ × 30⅜ in., OL.1980.1257

Fig. 18. John Hinchliff, engraver, after Karl Joseph Begas, Alexander von Humboldt, from *Cosmos: A Sketch of a Physical Description of the Universe* (London: Henry G. Bohn, 1849) vol. 1, frontispiece. OL.1984.376.1.

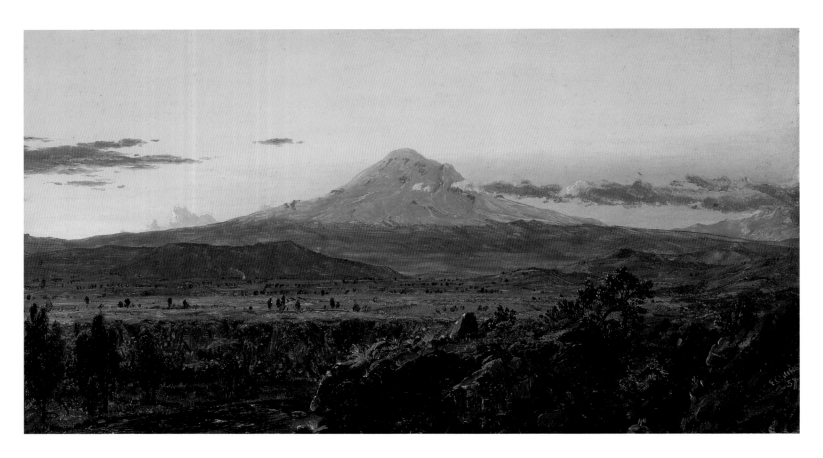

Cat. no. 7. Frederic Edwin Church,
Mount Chimborazo at Sunset, ca. July 1857,
oil on academy board mounted on canvas,
12 × 21⁷⁄₁₆ in., OL.1980.1884

of Earth's varied habitats, hot to cold, exhibiting a corresponding variety of flora and fauna. When Church, enthused by Humboldt's descriptions of a region virtually planetary in its climatic range, twice visited South America, in 1853 and 1857, he was hardly the first in a succession of promising acolytes. Humboldt had already stimulated, among others, Charles Darwin (whose discoveries served to date Humboldt's) to go there in 1832.[34] Compared to Darwin, Church was a scientific dilettante, but that mattered little since the scientist Humboldt was not only a popularizer but a grand humanist: in *Cosmos*, the *representation* of the natural world—that is, landscape painting—is extensively criticized, and the naturalist expressly urged artists to visit and depict the equatorial regions.[35] Not least crucial to Church's artistic ambitions in the southern hemisphere was that he could rely on the wide interest in Humboldt's writings to excite taste for his paintings.

During his second visit to Ecuador in 1857, in the company of the landscape painter Louis Rémy Mignot, much of Church's concentration was directed at Chimborazo, the country's tallest (20,577 feet) and broadest mountain. In 1802 Humboldt had clambered to within 1,300 feet of its summit (incidentally setting a world mountain-climbing

record that stood for thirty years) and later both diagrammed the mountain to illustrate his "geography of plants" and aestheticized it by likening its lofty aspect to "that majestic dome [of St. Peter's basilica], produced by the genius of Michael Angelo."[36] On his first journey to South America in 1853, Church's attempts to sketch Chimborazo had been frustrated by poor weather concealing the crown. In July 1857, however, he preserved the snowpeak in many pencil sketches, including one just after sunset that he soon turned into a haunting color portrait (cat. no. 7).[37] The view is from the southeast near Riobamba, a provincial capital in central Ecuador from where Church and Mignot trekked to the erupting Sangay volcano and back. As Humboldt reminded his readers, Chimborazo, like many of the iconic Andes of Ecuador, is an extinct or dormant volcano, neighboring many active ones.[38] Compared with the fiery sunsets of the artist's North American views, the cast of the twilight here, silhouetting the snows of Chimborazo (and Carguairazo, rising at the extreme right), is chill but accurate: at the equator, the sun drops abruptly (and always at the same hour) in the high, thin air behind the Andean cordilleras.

Fittingly, Chimborazo became the crowning background feature of *The Heart of the Andes* (fig. 19), Church's largest and most acclaimed landscape. Twelve thousand people saw the painting in New York alone in the first three weeks of May 1859, before it embarked on a two-year, paid-admission tour of Britain and eight other American cities.[39] Humboldt was never more germane to Church's enterprise than in this picture. By dint of its size and obsessive detail (fig. 20), *The Heart of the Andes* allowed the artist to approximate better than he ever had (or would again) the complexity and unity (in

Fig. 19. Frederic Edwin Church, *The Heart of the Andes*, 1859, oil on canvas, 66⅛ × 119¼ in., The Metropolitan Museum of Art, Bequest of Margaret E. Dows, 1909. (09.95), Photograph © 1979 The Metropolitan Museum of Art

Fig. 20. Detail of *The Heart of the Andes*, fig. 19

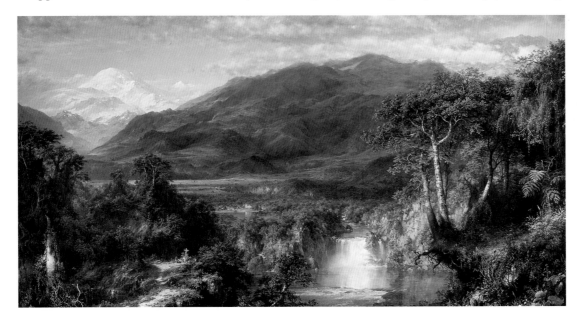

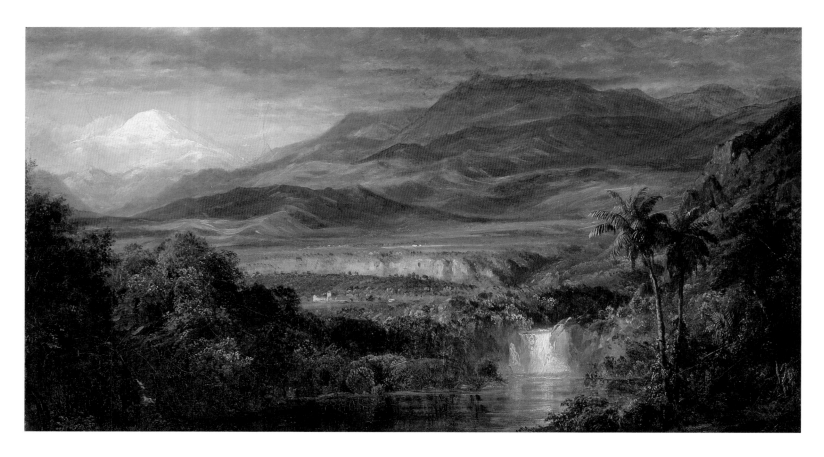

Cat. no. 8. Frederic Edwin Church, *Study for "The Heart of the Andes,"* 1858, oil on canvas, 10¼ × 18¼ in., OL.1981.47

that order) of Humboldt's Nature. The picture is a classical landscape rendering of the naturalist's geography of plants, with the flowery effulgence of its subtropical foreground giving way to the mild greenery of its temperate plain in the middle distance, thinning out into the bare brown ridge forming the near background, and, far off, the frigid dome of Chimborazo. All the essentials of the scheme were set out in the eighteen-inch oil study for the painting (cat. no. 8) now displayed in the East Parlor at Olana;[40] it even might be claimed that, in the study, the *unity* of Humboldt's geography is better achieved, chiefly because of the more generalized execution, suited to the scale and function of the image, but also due to Church's initial impulse to depict palm trees, indigenous primarily to tropical climes, in the foreground, rather than the compositionally stronger deciduous trees, suggestive of cooler habitats, that he preferred for the large painting. Chimborazo is a fainter presence in the study. By making the mountain prominent in the painting, and indeed by generally sharpening the forms and heightening the defining lights and shadows, the artist biased the science over the art of his ultimate conception. There he also seems to have added faith, by planting a wayside cross, attended by indigenous pilgrims, on the path in the left foreground. Yet minute inspection of the right foreground

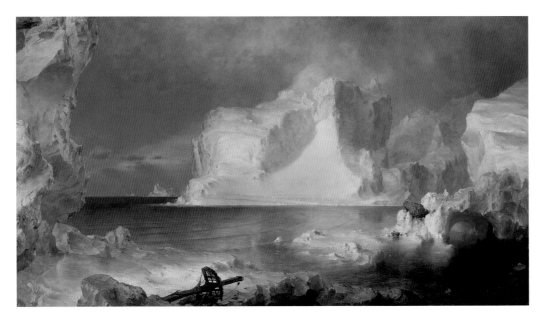

Fig. 21. Frederic Edwin Church, *The Icebergs*, 1861, oil on canvas, 64½ × 112½ in., Dallas Museum of Art, Anonymous gift, 1979.28

of the study reveals the pentimenti (not visible in the illustration) of a grotto shrine (to the Madonna and Child?) and a female worshiper at the base of the palm trees, indicating Church's impulse to Christianize the landscape even at a preliminary stage.[41] The change may be significant: the cross, though nestled in a far vaster context, will recall the one in *To the Memory of Cole* (see fig. 13) of a generation earlier, to say nothing of the crosses in the master's religious allegories. Even in Humboldt's Ecuador, Church quietly sowed and saluted the pious sentiment of his late artistic mentor.

Though Church never visited South America again after 1857, he continued to produce large landscapes of it, most of them prized by critics and the public, until well after the Civil War. He also turned his attention in the opposing direction, virtually to the frigid zone, when he sailed north in the Atlantic to near the Arctic Circle to sketch icebergs for a "Great Picture" (fig. 21) of those motifs that he exhibited, with little less acclaim than he had *The Heart of the Andes*, in 1861.[42] All this did not mean he lacked opportunities to sketch again in tropical habitats, but the next time he did, his results were often strikingly different, much because his travel—to Jamaica in the summer of 1865—was prompted by far different circumstances. Those require brief focus on his personal life at this time.

During the autumn of 1859, as *The Heart of the Andes* revisited New York for another and longer showing, Church met and fell in love with Isabel Carnes (fig. 22), of Dayton, Ohio, who is said to have sought an introduction to the painter. The following year the couple married and settled in a cottage on farm property in Hudson that he had just purchased and later would expand to become the site of Olana.[43] Two babies soon

Fig. 22. Sarony and Company, *Isabel Mortimer Carnes Church*, ca. 1868–70, albumen print, 5⁹⁄₁₆ × 4¼ in., OL.1992.9

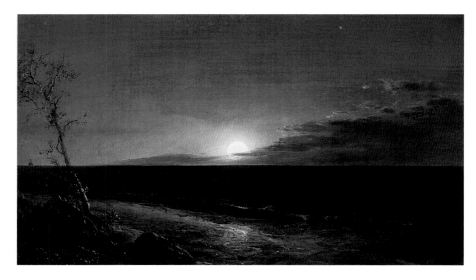

Fig. 23. Frederic Edwin Church, *Moonrise*
(*The Rising Moon*), January–March 1865,
oil on canvas, 10 × 17 in., OL.1981.11

Fig. 24. Frederic Edwin Church, *Rainy Season in
the Tropics*, 1866, oil on canvas, 56¼ × 84¼ in.,
Fine Arts Museums of San Francisco, Museum
Purchase, Mildred Anna Williams Collection,
1970.9

followed, Herbert Edwin and Emma Francis, in 1862
and 1864 respectively. To celebrate the new boy and
girl, the artist painted small pictures of a rising sun
and a rising moon (fig. 23). By any standard, the
Churches had been blessed, and this during the war,
one of the most anxious and mortal trials in America's
history. Privileged by his wealth, which enabled him
to avoid the military draft, Church like many of his
artistic colleagues had been spared direct involvement
in the conflict. But just before war's end, in March
1865, both his children were stricken with diphtheria
and died about a week apart.[44] Less than a month
later, the bereaved couple fled the farm and (in
Church's words) "our affliction" for Jamaica, "for
the change of scene, air and life."[45]

Accompanied by friends for the four-month
retreat, husband and wife did not sit and grieve. Isabel
enthused herself collecting the multitudinous species
of ferns on the island, while her husband launched
himself into one of the most intense and productive
plein-air sketching campaigns of his career. Some of
the results undoubtedly were instigated by the major
painting *Rainy Season in the Tropics* (fig. 24), which
Church had abandoned on its easel when his children
died. The bladelike roots of Jamaica's Blue Mountains
that caught the artist's attention in *Scene in the Blue
Mountains, Jamaica* (cat. no. 9) probably belong in this
category. The sketch is one of several made of the
mountains from opposing crests, 3,100 feet above sea
level, which Church may have scaled expressly to
gain a high vantage suggested by the one in the unfinished painting. But another divi-
dend of the climb would have been the opportunity to record the shifting wet weather
around the summits at eye level, as he did even more purposefully in several of the other
Jamaican oil sketches.[46] When he returned to *Rainy Season in the Tropics* the following
winter, he surely brought his fieldwork to bear.

Except for the highly detailed foregrounds of *The Heart of the Andes* and some of
his other tropical paintings, nothing in Church's known output up to 1865 explains
the large quantity and daunting intricacy of the botanical studies that he compiled in

Jamaica. In Colombia and Ecuador a decade earlier, the artist had executed many oil sketches of mountains and valleys, but his scores of botanical subjects depicted there are virtually all in pencil. None of those drawings approaches the bewildering impression made by the vertical oil sketch of slanting trees and heavily depending vines on a steep hillside (cat. no. 10).[47] The effect is both wondrous and oppressive: Church appears not to have missed a single leaf of those composing the vegetation as it mounts relentlessly toward the sun yet also seems smothered by its own parasitic forms. Not all such field studies are worked up to this degree; nonetheless, it is hard to divine (for instance, in Church's later work) the function of these dazzling exercises save for the sheer distraction from woe he gained by the compulsive will and focus their execution required. Or perhaps, in a spirit of solicitude, he harmonized himself artistically with Isabel's fern-collecting mania: "Mrs. Church," he wrote to a friend, "is insane on the Fern question."[48] One of the studies, which Church later framed for Olana, is literally of "the region known as Fern Walk."[49] For both husband and wife, surely, what they gathered

Cat. no. 9. Frederic Edwin Church, *Scene in the Blue Mountains, Jamaica*, August 1865, oil on paper mounted on academy board, 10⅝ × 17¾ in., OL.1981.69

Cat. no. 10. Frederic Edwin Church, *Tropical Vines and Trees, Jamaica*, ca. May–July 1865, oil on paper mounted on wood, 18⅛ × 12½ in., OL.1980.1948

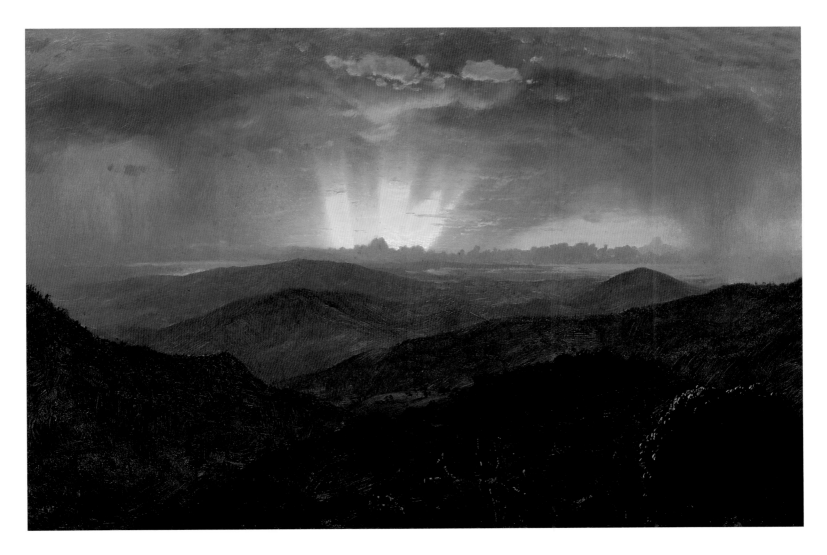

in image and specimen from their paradisiacal refuge helped summon their faith in regeneration.[50] Back on the farm, in September 1866, Isabel gave birth to Frederic Joseph, to be followed by three more children up to 1871. By that time Church was also hard at work building his castle to guard the family he and Isabel were re-creating.

Sunset, Jamaica (cat. no. 11) may be the ultimate testimony of Church's retreat on the island with his wife. The changeable weather they experienced there, already revealed in catalogue number 9, made for spellbinding sunsets and twilights comparable to those that inspired him in North America. Some, if anything, were even more explosive or turbulent in effect. He later confided to his father: "I might not see similar again."[51] Naturally, therefore, he snared a few, none more disquieting and "divine" than the bursting radiance he recorded in an annotated pencil drawing made in July 1865, which he

Cat. no. 11. Frederic Edwin Church, *Sunset, Jamaica*, July 1865, oil on paper mounted on canvas, 12⅛ × 18⅛ in., OL.1981.26

Fig. 25. Frederic Edwin Church, *Aurora Borealis*, 1865, oil on canvas, 56⅛ × 83½ in., Smithsonian American Art Museum, Washington, D.C./Art Resource, NY

converted quickly into catalogue number 11.[52] Perhaps, once again, a recent easel painting conditioned him to aerial effects: his *Aurora Borealis* (fig. 25), an arctic panorama completed in New York the winter before, was currently on view with two other paintings in London. That work, formulated at war's end, has been plausibly interpreted as a portent—triumphant and desolate, both—of the Union victory.[53] Whatever the Jamaican spectacle may have signified to Church at the time, two years later it assumed unmistakable memorial overtones when he amplified and concentrated its effects in a four-foot composition suggestively titled *The After Glow* (fig. 26). A cherished sister, Charlotte, had died in Hartford after a long illness in January 1867; Joseph Church purchased the painting from his son in November. When his father died, it passed to his elder sister Catherine but, at her death, the artist inherited the painting and hung it at Olana.[54] In enlarging on the sketch, Church warmed and focused attention more exclusively on the central radiance, darkening its surroundings and reflecting it in a lake he contrived for the middle distance. In the foreground at right he imposed the stone ruins of a chapel or church, possibly alluding to the family name, as he occasionally did in signing his letters.[55] The painting is impressive, but once may have been more so. Church retouched it twice, and it was conserved twice in the twentieth century.[56] One suspects

that *The After Glow* originally possessed greater spaciousness of effect. The oil study, with its still-airy foreground and middle distance and the remote ocean horizon for which the artist substituted the lake in the large picture, retains more of the revelatory flavor of the painter's first notice.

Even before leaving Jamaica for home in September 1865, Church felt eager to stretch the therapeutic run of field sketching. From the Blue Mountains in August, he wrote to a friend: "As I have made good use of my time here I can afford to have a brush at the Autumn tints in the States this fall."[57] New season, fresh scenery, ongoing diversion. In some degree his intention reflects a propensity observed, in 1859, in his turn from the Ecuador of *The Heart of the Andes* to the North Atlantic of *The Icebergs*. By early October he was in southwestern Vermont, near Rutland, the vicinity of his first visits to the state in 1848 and 1849, and where he seems first to have remarked on the beautiful twilights that would preoccupy him in so much of his work of the 1850s. Indeed, at Olana is one of his earliest studio paintings of such effects, *Ira Mountain, Vermont* (fig. 27), which the artist exhibited at both the National Academy of Design and the American Art-Union.[58] But *Ira Mountain* and other Vermont subjects of the time disclose that his early visits ended well short of the exceptionally brilliant autumns in that state. Before 1865, however, he traveled there one other time, in October 1863, and in the following year exhibited an *Autumn Landscape* at the Boston Athenæum. Evidently, by 1865 his attention had already turned toward New England fall scenery, and so, while still in Jamaica, he targeted Vermont to renew his familiarity with it.

Whatever the case, a large study such as *Blueberry Hill, Vermont* (cat. no. 12), inscribed on the back "Autumn Study/near Castleton Vermont/by F. E. Church," could not distinguish itself more from the romantic tenor of *Ira Mountain*, despite the presence in it of

Cat. no. 12. Frederic Edwin Church, *Blueberry Hill, Vermont*, ca. October 1865, oil on paper mounted on canvas, 12⅞₁₆ × 20½ in., OL.1980.1886

the same essential motifs—farmland, farmhouses, fields, copses, and fences—albeit in vastly different scale relationships.[59] It is as if the emphasis on the domesticated landscape that he preferred in the 1850s was inverted by his recent experience of the gigantism of Jamaican (see cat. no. 9) and, years earlier, Ecuadorian mountains. In its strict profiling of Blueberry Hill, Church's image evokes his drawings of the cordilleras, specifically of Pichincha, the volcano on whose slopes rests Quito, Ecuador's capital, and which was probably the essential model for the brown ridge filling the background of *The Heart of the Andes* (see fig. 19).[60] Like the Andean cordillera, Blueberry Hill dwarfs everything on its slopes and at its foot, including the locomotive puffing across the scene at left, supplanting the horse-drawn carriages that accessorize the early Vermont paintings.

More prosaically, this relatively spaceless, point-blank, broadside recording, barely composed by the orange birch trees punctuating it at either side and the schistlike rock that anchors it at lower right, seems an assertion of the essential subtlety of autumn coloring, even in Vermont. Perhaps the study is also a criticism of the gaudier chromatic

artifices in the paintings of Jasper Francis Cropsey, who was then just beginning to create a reputation in America as an autumn specialist. Church's orange trees are accents on a broad terrestrial palette of complementary mauves and greens. Distilling fall brilliance in the medium of air, the artist glosses neither earthly anatomy nor sylvan texture. The shadows of two tree trunks climbing the foreground rock seem an afterthought and probably were, but they function to weight the rock and restrain the opposing thrust of the forest lines on the mountain. *Blueberry Hill* is a composition after the fact; it is a field study first.

Church is unusual among his contemporaries in having ignored the grand tour of the Old World as a prerequisite of his artistic enterprise. Alone among his peers, he had heeded Humboldt's invocation to painters to visit the jungles and heights of the equatorial New World, and his representations of them marked his artistic maturity and ensured his fame. Without the domestic trials of his life, would he ever have crossed the Atlantic, as he did in October 1867, remaining in Europe and the Near East for almost two years? To be sure, after the Civil War, hosts of affluent Americans went abroad. A few of Church's fellow landscape painters, such as Sanford Gifford, even returned for second visits, at least partly in expectation of winning commissions from fellow citizens seeking souvenirs of the picturesque cities and resorts they had toured. Indeed, it was Gifford who, in November 1868, welcomed the Churches to Rome, where Church's former pupil Jervis McEntee, the portraitist George Peter Alexander Healy, and the poet Henry Wadsworth Longfellow were among the Americans then sojourning there.[61] Later, the three painters would collaborate on a monumental painting (fig. 28) showing Church sketching relief sculpture on the Arch of Titus while McEntee and Healy criticize his work and Longfellow and his daughter pose beneath the arch.[62] The image fairly reflects the artist's concerted architectural orientation in visiting the Old World: just before sailing from New York, Church not only bought the hilltop site of his future home above the Hudson but studied architectural drawing in New York, presumably to grasp better the forms of edifices that might both become subjects of his paintings and serve as models for his domicile.[63] In truth, however, Church disliked Rome—the traditional mecca of the grand tour— and its ancient and Renaissance (and Roman Catholic) buildings.[64] He landed in the Eternal City only after making his destination the Near East, specifically the sites of Holy Scripture: Egypt (briefly), Palestine, Lebanon, and Syria.

In great measure, the retreat and reaffirmation sought in Jamaica were being extended and perhaps fulfilled in the Holy Land. Isabel, her mother, Emma Carnes, and the couple's toddler Frederic Joseph Church (fig. 29), all accompanied the artist, and while abroad the couple would conceive and produce another child, Theodore Winthrop Church.

Fig. 28. Frederic Edwin Church, George Peter Alexander Healy, and Jervis McEntee, *The Arch of Titus*, 1871, oil on canvas, 73½ × 49 in., The Collection of The Newark Museum, Bequest of Dr. J. Ackerman Coles, 1926

Fig. 29. Attributed to Frederic Bonfils, *Frederic Edwin Church and His Son, Frederic Joseph, in Beirut,* 1868, carte de visite, photograph, 4⅞ × 3⅜ in., OL.1984.446

Fig. 30. Frederic Edwin Church, *Jerusalem from the Mount of Olives,* 1870, oil on canvas, 54¼ × 84⅜ in., The Nelson-Atkins Museum of Art, Kansas City, Missouri, Gift of the Enid and Crosby Kemper Foundation, F77-40/1, Photo: Robert Newcombe

Church first settled his family in Beirut, among a large American and British community of missionaries and tourists flooding the Near East in the post–Civil War period.[65] The enterprise of many of the former was biblical archaeology, the verification of scriptural account through expedition to and excavation at sacred sites identified in both the Old Testament and, especially, the Gospels. In one respect, at least, Church's agenda had not changed: the pursuit was ostensibly empirical, though the presumed reward was spiritual. William Walter Phelps, brother of the founder of the Syrian Protestant College (later the American University of Beirut) and a companion of the artist in the Holy Land, insisted: "Equally logical are the processes of science and religion," a conviction that the artist's own Calvinist faith, with its fervent adherence to the Word, seemed ideally to accommodate.[66] Some of this religious prospecting Frederic and Isabel undertook together. In March 1868 she reported that she and her husband had read from the New Testament while pausing at the Mount of Olives overlooking Jerusalem.[67] There, unlike in much of the teeming city, they could imagine Jesus still afoot and preaching. It was also there that the artist made his drawings for *Jerusalem from the Mount of Olives* (fig. 30), the most important painting known today resulting from his Old World sojourn. Church imbued the distant city with a preternatural glow that lifts it gloriously above the surrounding terrain.

Headquartering in Beirut allowed Church, just one month after his arrival in the Near East, to leave his family secure while he set out with the Reverend D. Stuart Dodge, Alexander Fowler, a Scotsman, and their guide, Michail Hené, on a four-week trek via boat and camel to the lost rock city of Petra, in present-day Jordan. They arrived there via Mounts Hebron, Carmel, and Hor, on 24 February 1868.[68] Inhabited by the Edomites and Nabataeans in Old Testament times, Petra became part of the Roman province of Arabia Petraea in the second century A.D., was subsequently Christianized until occupied by the Muslims in the seventh century, then was seized by the Crusaders in the twelfth. They reportedly built a citadel there, but for many centuries the site was lost to Westerners until rediscovered by a German archaeologist in 1812. Above all, perhaps, Petra for Church was an enigmatic novelty of ancient civilization revealed. "It is wonderful," he wrote to his friend the Albany sculptor Erastus Dow Palmer, "and yet for Centuries its very location was unknown—Who built it?—The Bible tells—It is Edom the inheritance of Esau. . . . It was conquered by various powers—But it was the object of terrible prophesies and is

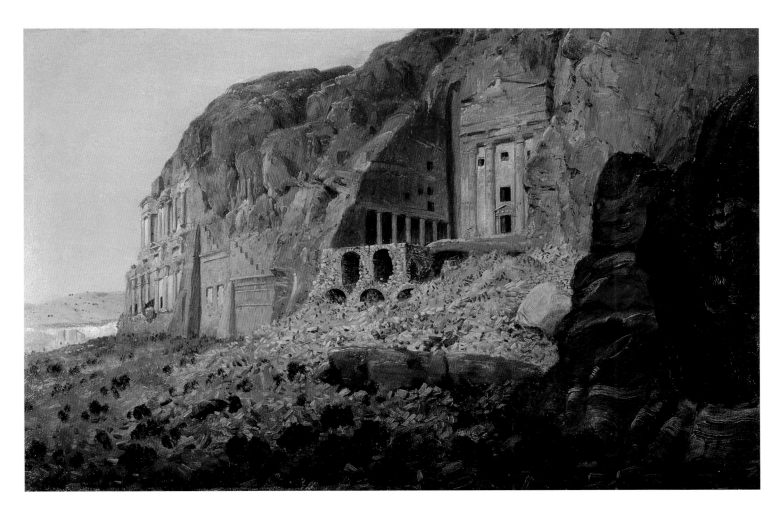

now the strangest scene of desolation I ever saw."[69] (The prophesies are in Jeremiah [49:17–18]: "Edom shall become a horror . . . no man shall dwell there.")

For an artist of Church's orientation, the *way* ancient civilization is revealed at Petra must have been especially intriguing, and seems communicated in the oil study *The Urn Tomb, Silk Tomb, and Corinthian Tomb, Petra* (cat. no. 13), which he executed probably just days after sketching the scene in pencil, on 26 February. There the existing "buildings" are not constructed but carved out of the stone and, worn by centuries, appear almost latently in the natural rock like prehistoric fossils. (In another way of thinking, they seem, Pompeii-like, to have been immured in stone poured by geologic forces.) Eleven years earlier Church had punctuated his second tour of Ecuador with a five-day trek from Riobamba to see close-up the erupting Sangay volcano. The experience of traveling over the increasingly volcanic terrain toward the mountain is probably reflected in the desolate foreground of *Cotopaxi* (fig. 31), whose red-orange color scheme anticipates the

Cat. no. 13. Frederic Edwin Church, *The Urn Tomb, Silk Tomb, and Corinthian Tomb, Petra*, March 1868, oil on paper mounted on canvas, 13 × 20⅛ in., OL.1981.52

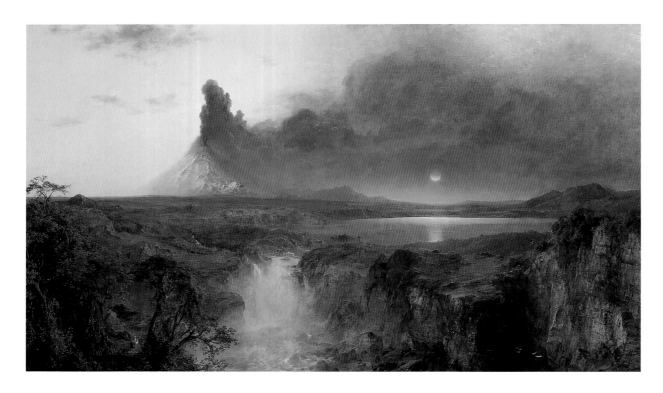

Fig. 31. Frederic Edwin Church, *Cotopaxi*, 1862, oil on canvas, 48 × 85 in., The Detroit Institute of Arts, Founders Society Purchase, Robert H. Tannahill Foundation Fund, Gibbs-Williams Fund, Dexter M. Ferry, Jr., Fund, Merrill Fund, Beatrice W. Rogers Fund, and Richard A. Manoogian Fund, Photograph © 1985 The Detroit Institute of Arts

pink stone the artist found at Petra. Now, both natural history *and* human history were to be discovered in a glance, expressed in the same material. Virtually devoid of vegetable life, Petra embodied a civilization long abandoned and irrecoverable and, therefore, eloquent. This appealed to Church far more than did the ruins that ornamented the peopled cities of Jerusalem and Rome. "Syria," said Church of the region including Petra that he identified by that name, "with its barren mountains and parched valleys possesses the magic key which unlocks our innermost heart."[70] The oil study seems to have been one of the few of his Near Eastern studies that he eventually framed for Olana.[71]

Church was not the first artist to image Petra, but the few precedents were chiefly in engravings, most notably the volume of lithographs *The Holy Land* (1856), by the renowned English artist David Roberts.[72] Church undoubtedly knew these prints and may have been guided by their points of view. Roberts's conceptions are splendid in their way: he tended to aggrandize the rock tombs by vertically stylizing, even "architecturalizing" the surrounding cliffs and by clearing away the talus and rubble at the site that are so conspicuous in the foreground of Church's study. Roberts's lithograph of El Khasné (fig. 32), which was then and is now the highlight among the rock tombs or temples at Petra, closely anticipates Church's painting of the edifice seen through the Sik (cat. no. 1), the narrow fissure in the cliffs that so dramatically frames the entryway. Roberts orchestrated the spectacle of the pale facade beyond the gloomy gorge, not simply by the tonal

contrasts he managed between it and the rock walls but by the orthogonal rays he fashioned from the geologic strata, suggesting the diffusion of the facade's brilliance. But Church enjoyed the latitude and luxury of working in oil colors, which at Petra must have enlivened the otherwise bloodless aridity of the place. Just after characterizing to Palmer the "desolation" of Petra, he added, almost breathlessly:

> There are the most wonderful rock colors here that I ever saw—The Khasné is a pretty uniform [hue]—but usually the most gorgeous colors blend in waving stripes, crossed by bars of varied tints[.] The most astonishing effects are produced, especially in the cuttings of the Tombs &c—purple shades into varied tints of red and orange purple and grey follows the same waving lines[,] perhaps a rich orange blending into lemon yellow follows with white edging. Usually the graded tints of red alternate with purple & grey. Certainly I never saw anything so gorgeous.[73]

El Khasné's color may have been "pretty uniform," but, as Church wrote to his friend William Osborn, "this lovely temple shows the true color of the rock—a luminous reddish salmon tint—a tea rose color. By contrast with the black precipices [out of which it is cut] it shines as if self illuminating."[74] Indeed, he invited Palmer to "imagine this fairy like Temple blazing like sunlight among those savage black rocks."[75] The artist mediated both descriptions in the painting. Had he given full play to the "tea rose color" he identified, he could not have achieved the "blazing sunlight" he sought. Thus he used the "reddish salmon" for the recessed stone that relieves the paler orange and yellowish tints selected for the projecting elements. Unlike Roberts, with his linear expression of the facade's radiance on the periphery of his image, Church naturalistically reflected its incandescence, faintly on the opposing near walls of the gorge, shimmeringly in the stream that floods the Sik and irrigates the brush. (In the gloom of the gorge at left two armed Bedouins, of the kind that Church feared might interdict his work at Petra, guard the gateway as if still to shield the once-lost city from Western gaze.) Otherwise, obscurity, right up to the picture's borders, fairly contains and accentuates the revelation created by El Khasné's pale visage. In terms of presentation, the strategy was not really new to Church: in 1859 he had made *The Heart of the Andes* seem "self-illuminating" by installing it in a windowlike, black walnut frame, then darkening the gallery save for the daylight that he channeled exclusively on the image.[76] At Petra, theater and reality seemed to have met in El Khasné; Church revealed that on first sight he "was too astounded to do anything but stare at the temple for some time."[77] Just as he did for Osborn and Palmer, he could only describe the vision of Petra and El Khasné to Isabel, whom he had left behind in Beirut. It is no wonder, among other reasons, that he gave her the picture for their home (see fig. 1).

Fig. 32. David Roberts, *Temple of El Khasné, Petra*, lithograph, from George Croly, *The Holy Land, Syria, Idumea, Arabia, Egypt, & Nubia* (London: F. G. Moon, 1842–49), vol. 3, frontispiece, Excavated Temple of Petra, The Dorot Jewish Division, The New York Public Library, Astor, Lenox and Tilden Foundations

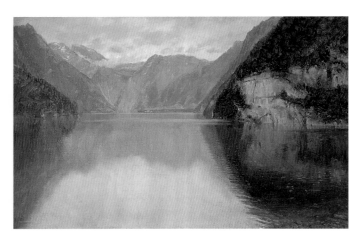

Fig. 33. Frederic Edwin Church, *Königssee, Germany*, July 1868, oil on paper mounted on canvas, 13 × 20 in., OL.1981.42

Once Church and his family had completed their pilgrimage in the Holy Land, exploring among other places Jerusalem, Damascus, and Baalbek, they departed by boat for Western Europe via Asia Minor, with pauses in Turkey, Germany, Austria, Switzerland, and Florence before arriving in Rome in early October 1868.[78] In July, Berchtesgaden and especially Königssee, a lake in the Bavarian Alps, gave "great delight" to Isabel;[79] perhaps Church was obliging her by making several sketches of the lake in oil (fig. 33), even as he confided to Osborn that "Magnificent and stupendous as the scenery is here—yet I look back with particular favor to the sad—parched—forsaken Syria. There is poetry—not here."[80] Still, if his lake sketches communicate mere excitement, a small, suggestive oil study of a rainbow among mountains (cat. no. 14), based on a quick sketchbook drawing, elicits poetry from the alpine landscape. Annotations on the verso of the drawing indicate that Church actually witnessed this phantasmal iris, but it would be hard to deny that the artist's own *Rainy Season in the Tropics* (1866; see fig. 24) had not informed his tender fashioning of generalized landscape and aerial forms, which he quickened, much as in the large painting, with select sharply focused passages.[81]

With the Hudson property awaiting his return, Church knew that his mission in the Old World must include one last excursion. His architectural studies in New York in preparation for the trip reportedly had included copying from engravings of the Parthenon in Athens.[82] Though surely the design of the Western world's foremost architectural ideal would have no bearing on the home the artist planned for Hudson, perhaps its hilltop setting and the stark yet noble impression it makes on the Acropolis would.[83] In that respect, an edifice such as the secreted El Khasné was no inspiration. At any rate, the Parthenon demanded he pay his respects, even if he must wait until after Isabel gave birth to their son Theodore in February 1869. A little more than a month later he set out for Athens, stopping among other places in the former Greek colonies at Paestum, Corfu, and Corinth. Having been unimpressed with Roman antiquities, Church found himself unexpectedly awed by the Parthenon:

> Every column, every ornament, every moulding asserts the superiority which is claimed for even the shattered remains of the once proud temple over all the buildings created by man. . . . [I] fancied before I came to Athens that I had a good idea of [the Parthenon's] merits, but in reality I knew it not. Daily I study the stones and find its inexpressible charm and beauty growing on my senses.[84]

The "shattered" condition of the remains to which Church referred was the product of an explosion that occurred when gunpowder stored in the building by the former Turkish rulers of Greece was hit by a shell during their war with Venice in the late

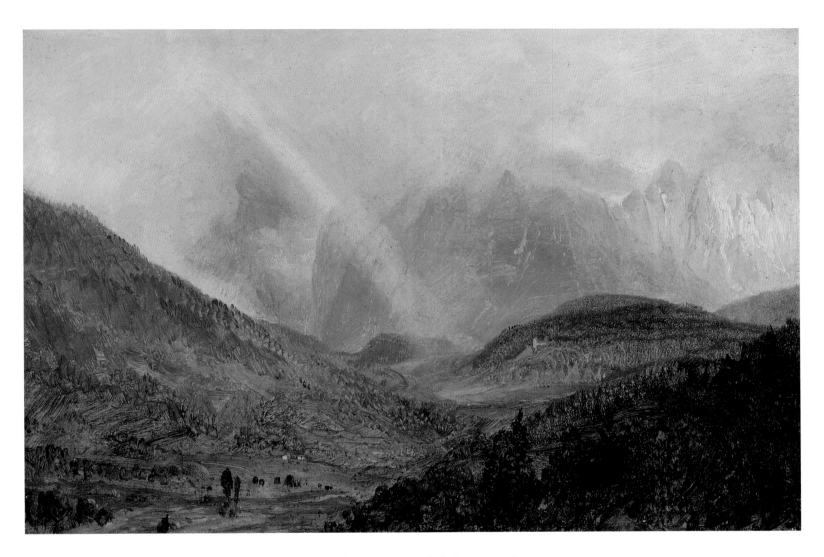

seventeenth century. Though in none of his images of the monument did the artist gloss the marble fragments strewn over the Acropolis by the disaster, in the oil sketch of the Parthenon that he framed for Olana (cat. no. 15), his vision savors of Cole's in the mild daylight. The wizened building abides amid encroaching vegetation on the mount. (Church's other Greek subject at Olana is a shady grove of olive trees.)[85] In the finished painting commissioned by Morris K. Jesup (fig. 34), Church reasserted the architectural paragon in spite of its wounds, by moving closer to it, playing it off foreground shade, and hardening it in the thick light of sundown.

On his return to America in June 1869, Church began to spend more and more time upstate. That summer he and Isabel conceived their last boy, Louis Palmer Church, born the following April, and a little more than two years later completed their family with

Cat. no. 14. Frederic Edwin Church, *Rainbow near Berchtesgaden, Germany*, July–August 1868, oil on paper mounted on canvas, 8 3/16 × 11 15/16 in., OL.1980.1883

Cat. no. 15. Frederic Edwin Church, *The Parthenon and the Acropolis, Athens*, April 1869, oil on paper mounted on canvas, 11½ × 20¼ in., OL.1981.74

Fig. 34. Frederic Edwin Church, *The Parthenon*, 1871, oil on canvas, 44½ × 72⅝ in., The Metropolitan Museum of Art, Bequest of Maria DeWitt Jesup, from the collection of her husband, Morris K. Jesup, 1914. (15.30.67), Photograph © 1986 The Metropolitan Museum of Art

Isabel Charlotte, their only surviving girl, born in July 1871. Correlatively, what Church in Europe had described to his friend William Osborn as his "modest, substantial house for a permanent home" began to rise on the hilltop, under his close supervision and with his steady participation in its design. "Why shouldn't I have the advantage of it for my family?" he had asked rhetorically. Alluding to his architectural research and, no doubt, his life experience, he added: "When you build, build of stone—never be tempted to build of wood."[86]

Thus anchoring himself more often to his property, Church over the next several years executed a slew of oil sketches from and of his estate, venting the affection for the Hudson River Valley and Catskill region that he had developed while studying under Cole a quarter century earlier. The activity was no doubt further stimulated by his acceptance of two pupils, Lockwood de Forest III, a distant relative of Isabel, and Walter Launt Palmer, son of his sculptor friend, with whom he certainly sketched on the grounds.[87] Sunsets and twilights over the Catskills were essayed frequently, of course; indeed, Church had done a few of those in the previous decade. What was new were winter prospects, many oriented to the south, down the river. He produced more than twenty, possibly all in the winters of 1870–71 and 1871–72.[88] They are spontaneous and vivid renderings, but the most distinctive may be catalogue number 16, with its vertical format accommodating not merely the frozen terrain but the play of brilliant nimbus clouds in a high, cold heaven deepening to a sonorous blue.[89] The dashing in of pasty white for the clouds, and their resulting vitality, looks forward to the Impressionism of William Merritt Chase in the 1890s. The whole is artfully unified and barely warmed by the pink accents in the clouds, on the distant Hudson, and on the snow at the very base of the picture. The artist was certainly pleased with it, since he later framed the sketch for the house.

Not long before moving into his castle in October 1872, Church spied some "splendid sky effects" above Olana that he fixed in two oil sketches (cat. no. 17; fig. 35) of enormous

Cat. no. 16. Frederic Edwin Church, *The Hudson Valley in Winter from Olana*, ca. 1871–72, oil on paper mounted on canvas, 20¼ × 13 in., OL.1981.14

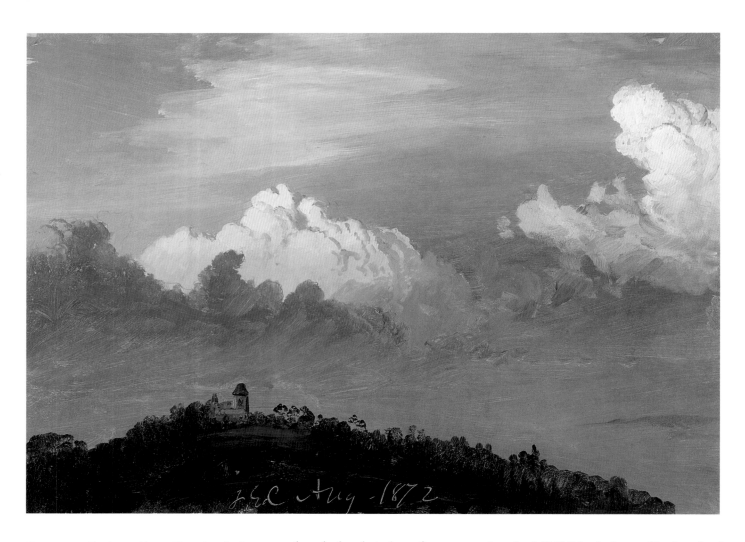

Cat. no. 17. Frederic Edwin Church, *Clouds over Olana*, August 1872, oil on off-white paper, 8¹¹⁄₁₆ × 12⅛ in., OL.1976.1

thunderheads in late afternoon and at dusk.⁹⁰ With the butt of his brush, the artist initialed and dated both, August 1872; they were probably done within moments of one another, but only catalogue number 17 includes the house on the crest of the Sienghenbergh. These are among the few later paintings in which he approximated the kind of plastic muscularity in rendering clouds that is familiar in the western landscapes of his colleague and rival Albert Bierstadt but that is common in his own North American subjects of the 1840s and early 1850s (see figs. 11–13). The mushrooming cumuli suggest mighty cherubim, or the fantasy or celestial architecture that Cole (see fig. 8) and the British painter John Martin contrived for their allegorical landscapes. Were the house and hill truly present among the clouds when Church sketched them? Or did he pose them there as a significant afterthought, reaffirming his special connection since boyhood to the clouds and sky, nearer to which he would now dwell? The image evokes

a phrase from St. Paul's letters that Church would much later have translated into Arabic, perhaps to inscribe it somewhere in his home: "For every house is builded by some man, but he that built all things is God."[91]

A few years earlier, perhaps in a moment of fulsome pride, Church wrote to Palmer, "Almost an hour this side of Albany is the Center of the world—I own it."[92] With his recent travel, refreshed artistic agenda, current preeminence among American landscape painters, regenerating family, expanded property, and ambitious plans for building on it, he (and Isabel) may have felt that he had fully regained his stride. To the same correspondent, two months later, in September 1869, he confided, almost offhandedly: "I have got a very lame wrist and it pains me not a little to write this letter—but I have been waiting for some time for it to get better and it dont [sic]."[93] Nor did it. The symptom marked the onset of rheumatoid arthritis, which would plague the last third of his life. By 1875 the painter sometimes resorted to his left hand to make his art; by 1881 his entire body was showing signs of the affliction. He could no longer execute major paintings and occupied himself more and more with improvements to the house and grounds, which he had operated as a farm. At the same time, taste for Church's work and, indeed, for that of most of his landscape-painting colleagues in New York was declining. In the wake of the Civil War, Americans' cultural orientation abroad shifted increasingly away from Great Britain to the Continent, especially France, where the Barbizon School of painters championed an intimate and painterly mode of landscape that would be adapted by American artists led by George Inness. A measure of both Church's shrinking reputation and very visibility in the art world is the caption to a photograph of the Sienghenbergh crowned by Olana in a Hudson River tour guide published in 1888 that refers to the mansion as the home of Frederick *Stuart* Church (no relation), a younger painter of fanciful figural subjects.[94]

Isabel's health wavered along with her husband's, and, for both, the long, cold winters upstate became unbearable. In 1881 they made what for Church was the first of fifteen seasonal visits to Mexico up to and including the year of his death, 1900 (fig. 36).[95] (For her part, Isabel was soon compelled by her ailments to sojourn annually in the southeastern states or Bermuda, and she rejoined her husband at Olana in the

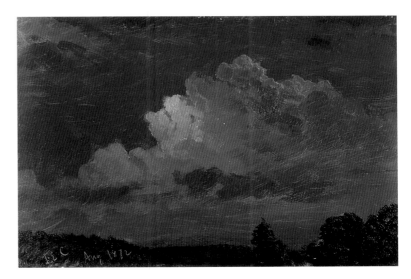

Fig. 35. Frederic Edwin Church, *Nightfall near Olana, Hudson, New York*, August 1872, oil on paperboard, 9½ × 14⅛ in., Cooper-Hewitt, National Design Museum, Smithsonian Institution, Gift of Louis P. Church, 1917-4-587, Photo: Matt Flynn

Fig. 36. Walter Launt Palmer, *Church on a Balcony in Orizaba, Mexico*, 1895, photograph, 2¼ × 3⅜ in., OL.1992.52.35

Fig. 37. Kurt Dolnier, *Studio at Olana*, photograph, 1997, © Kurt Dolnier

Cat. no. 18. Frederic Edwin Church, *Mexican Forest—a Composition*, 1891, oil on canvas, 14⅛ × 20⅞ in., OL.1980.1925

early spring.) In the main, these annual visits were tonic for the painter. Besides the refuge from the cold that the country afforded, Mexico, with its own snowcapped volcanoes and steamy jungles, sustained Church's sympathies for the varied habitats of the equatorial regions of South America that he had explored long ago in response to Humboldt, for whom Mexico had also been a destination nearly a century earlier and a subject of much commentary in his books. Mexico stimulated Church to copious sketching, which seemed to have a therapeutic effect despite the artist's limited dexterity. In 1884, the same year that Isabel's mother described Church as "so thin, pitiful to see," Howard Russell Butler, a young painter who accompanied the artist to Mexico, observed that Church "always seems better after sketching."[96] To be sure, he never lost his essential optimism and desire to work. In 1888, long after he realized that he could no longer paint large pictures and gave up the studio he had rented in New York for thirty years, he began building a new, commodious one at Olana (fig. 37).[97]

The completion of new working quarters in the winter of 1890–91, as well as Church's confinement to Olana that season for health reasons, occasioned the last

"treasure" chosen for this exhibition. The intimate, tender, yet haunting *Mexican Forest—a Composition* (cat. no. 18) seems highly unusual in Church's oeuvre. At first glance it might appear a concession to contemporary taste for Barbizon School–inspired wood interiors of the kind then very familiar in the work of George Inness and his followers—right down to the sunlight glowing softly on select tree trunks (fig. 38)—the kind of landscape that contemporaneous taste preferred to Church's earlier panoramas. The link cannot be ruled out, but the painting may be interpreted in multiple contexts that broaden its significance. With reference to his own past work, *Mexican Forest* most recalls Church's numerous oil sketches of jungles painted in Jamaica a quarter century earlier. Only latently does one's contemplation of the picture reveal that the composition is dominated by one grand bole, right of center, out of which other, smaller ones appear to generate. Its presence suggests Church's awareness of a well-known, prodigious cypress tree—reportedly fifty-two feet in diameter—at Santa Maria del Tule, near Mitla. The artist did not actually see the cypress until 1894, though he already may have owned a photograph of it.[98] But paternal trees appear like leitmotifs in Church's work throughout his career, starting with the two paintings of Hartford's renowned Charter Oak that he painted while still a student of Cole (fig. 39), continuing with the massive, clawed trunk portrayed in one of his finest North American oil sketches (fig. 40), to the great "oak," blazed with his own name, that anchors the left foreground of *The Heart of the Andes* (see fig. 20).

 To the historian, however, what lends particular soul to the work is the iconography, not merely of the great tree but of the small but conspicuous white bird, which flies through the space of the forest left by the trunk filling the right foreground. Formally, the bird, along with the patches of blue sky opened above it, focuses the light passages

Fig. 38. George Inness, *Sunset in the Woods*, 1891, oil on canvas, 48 × 70 in., Corcoran Gallery of Art, Washington, D.C., Museum Purchase, Gallery Fund, 91.10

Fig. 39. Frederic Edwin Church, *The Charter Oak, Hartford*, early 1846, oil on canvas, 22⅛ × 30⅛ in., OL.1981.16

Fig. 40. Frederic Edwin Church, *Probably Maine Landscape, In the Woods*, 1850–60, oil on paperboard, 14⅛ × 11⅛ in., Cooper-Hewitt, National Design Museum, Smithsonian Institution, Gift of Louis P. Church, 1917-4-589-c, Photo: Scott Hyde

Fig. 41. Asher B. Durand, *Kindred Spirits*, 1849, oil on canvas, 46 × 36 in., Collections of The New York Public Library, Astor, Lenox and Tilden Foundations

that balance the highlighted tree trunk on the right side of the composition and helps to define the clearing. The latter function recalls that of the birds in the wood interiors of Asher B. Durand, the grand, old, recently deceased father-figure of the second-generation Hudson River School. Durand had exploited birds to most suggestive effect in his memorial to Cole, *Kindred Spirits* (fig. 41), where a pair of them corresponding to the figures of Cole and the poet William Cullen Bryant, who stand on a rocky platform overlooking a forested ravine, intimate the idea of artistic and poetic afflatus. Alternatively, Cole points in the direction of the farther, yet more visible, of the birds, in a possible allusion to his departed spirit.[99] Could Church's angelic avian have borne comparable significance, especially in conjunction with the ancient, awesomely physical tree which, in effect, sires those around it? Are we to believe that the artist could have so closely identified with such features?

Probably, and more so at this stage of his life than ever before. Consider it in light of his sentiments at the time, that he had not produced enough pictures expressly for his

family.[100] Consider it, also, along with another painting that he executed simultaneously in his new studio, *The Iceberg* (fig. 42).[101] If *Mexican Forest* was informed by the jungles of Jamaica and South America, *The Iceberg* recalled even more literally his experience on the North Atlantic in 1859. Its composition of an explorer's ship before a mammoth ice castle is based on Church's illustration of the same subject matter, only portraying *The Integrity*, the sloop that he had actually sailed on. The pair of cabinet paintings are, of course, deliberate antipodes, much as the public masterpieces, *The Heart of the Andes* and *The Icebergs* (see figs. 19, 21), had been three

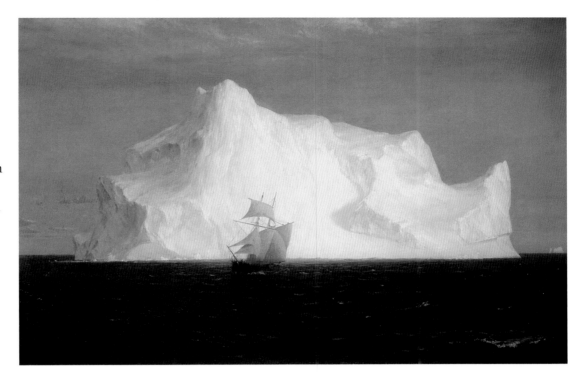

Fig. 42. Frederic Edwin Church, *The Iceberg*, 1891, oil on canvas, 20 × 30 in., Carnegie Museum of Art, Pittsburgh; Howard N. Eavenson Memorial Fund for the Howard N. Eavenson Americana Collection, 72.7.3

decades before. Those paintings, the earliest major products to come from what was then his new studio on Tenth Street in New York, had reflected Church's ambition to encompass pictorially the earthly component, at least, of Humboldt's cosmos. The late paintings, remarkable flourishes from one as physically disabled as Church had become, reprise not so much Humboldt as those halcyon times in understandably personal and nostalgic ways, and may subtly address his mortality and sense of personal legacy.

Surely, by this time Church, according to a visitor to Olana, felt "that his country has not known his value."[102] More than aesthetic culture had left him behind. His old hero Humboldt, with his ideal notions of natural unity that had dovetailed so well with the artist's religious convictions, had long been eclipsed by Darwin, who had discovered something else: earthly life driven by natural selection of traits and species based on mortal competition to survive, and a perceptible zoomorphic trail from human beings to great apes, and thus on down through the rest of the animal world. Where was God's place in this new cosmos? Though the large library of scientific and expeditionary literature that Church amassed at Olana included Darwin's works, there were two significant exceptions: *On the Origin of Species by Means of Natural Selection* (1859) and *The Descent of Man and Selection in Relation to Sex* (1871).[103] As early as 1883 the artist could wish: "Would that science had rested for ten years."[104] In faith, God might be constant, but not human knowledge, which increasingly seemed to challenge, or at least alter, divine reality and

Fig. 43. Frederic Edwin Church, *Church of San Francisco, Cuernavaca, Mexico*, January–February 1898, oil on tan board, 7¾ × 11½ in., OL.1977.226

design as interpreted in the Bible. In this context, what is one to make of the Mexican church subjects (fig. 43) that characterized the artist's production for the rest of his last decade? Ostensibly, they reflect Church's interest in architecture, and in human and Christian history. Yet, cloudless and inanimate, they emanate little that seems transcendent, but rather an eerie sense of isolation, vacancy, even alienation, that one associates with the paintings of Edward Hopper in the first half of the twentieth century—where the name of Frederic Church would have no place.

Probably, it is fairer and wiser to see the late ecclesiastical pictures as the regimen of a very sick man who was once a very distinguished artist. As paintings, they are pale reflections of what had been. Only their subjects may bear us back to where we started: that dazzling rock temple (El Khasné) within a stone fortress (Olana), still guarding its treasures. Thankfully, Church built something that survived a half century of oblivion before his gradual revival after World War II. The house, its artifacts, and its paintings are a wonder, but the ultimate dividend of our day at Olana may be to turn from the art to the views outside the windows and entranceways that Church so thoughtfully plotted to frame prospects in almost every direction, especially the view over his lake to the Hudson River and the Highlands farthest to the south. Like all great landscapes, those inside Olana improve the look of those we inhabit.

No one dealing cogently with the Olana collection can ignore the magisterial two-volume *Frederic Edwin Church: Catalogue Raisonné of Works of Art at Olana State Historic Site* by Gerald L. Carr. As the innumerable references to it in the following notes make clear, it is the indispensable source for any and all of the Frederic Church holdings. In its biographical introductions to the major phases of the artist's work represented at Olana, the catalogue is also the closest narrative of his earlier and later life. Also very helpful on the house itself and its contents has been *The Historic Furnishings Report for Olana State Historic Site*, prepared by former Olana Curator Karen Zukowski. The pioneering scholarship of David C. Huntington was critical to the revival of Church's reputation in the 1960s, but the past two decades have seen the most significant amplification of Church studies: Franklin Kelly's *Frederic Church and the National Landscape* (1988) and the catalogue Kelly prepared for the retrospective exhibition he organized for the National Gallery of Art in 1989; John Davis's *The Landscape of Belief: Encountering the Holy Land in Nineteenth-Century American Art and Culture* (1994), with its culminating chapter on Church's Near Eastern travels and subjects; and Gerald Carr's catalogue, *In Search of the Promised Land: Paintings by Frederic Edwin Church* (2000), to name a few. The author is indebted to them all, as well as to the friendly guidance, collaboration, and assistance of Evelyn Trebilcock and Valerie Balint, Curator and Associate Curator at Olana, in the preparation of this exhibition and catalogue. He and the curators are grateful to Chairman Jazz Johnson, President Sara Griffen, and Vice President for Development of The Olana Partnership Robert Burns; Site Manager of the Olana State Historic Site Linda McLean; Paper Conservator Marie Culver, Paintings Conservator Joyce Zucker, Frame Conservator Eric Price, Curator Robin Campbell, and Collections Manager Anne Cassidy, Peebles Island Conservation Center, New York State Office of Parks, Recreation and Historic Preservation, Waterford, New York. The curators appreciate the assistance of Suzanne Smeaton and Eli Wilner & Company in reframing four of the paintings in the exhibition. Finally, the author thanks Fronia W. Simpson for her scrupulous and sensitive editing of the manuscript and Morrison H. Heckscher, Lawrence A. Fleischman Chairman of the Departments of American Art,

The Metropolitan Museum of Art, for blessing the author's participation in this project.

1. Gerald L. Carr, *Frederic Edwin Church: Catalogue Raisonné of Works of Art at Olana State Historic Site*, 2 vols. (New York: Cambridge University Press, 1994), vol. 1, p. 388. It is thought that El Khasné was given its name by local Arabs who believed it to have held the treasure of an ancient Egyptian pharaoh.

2. Ibid., p. 395: Carr observes that El Khasné "became a synonym for Olana," since, as noted below in the text, "Olana" refers to an ancient treasury in Persia. See also Karen Zukowski, *The Historic Furnishings Report for Olana State Historic Site* (Hudson: The Olana Partnership and New York State Office of Parks, Recreation and Historic Preservation, Olana State Historic Site, 2001), pp. ix, 113.

3. Gerald L. Carr, *Olana Landscapes: The World of Frederic E. Church* (New York: Rizzoli, 1989), p. 2; Zukowski 2001, pp. 111–113.

4. For example, Church to John Ferguson Weir, 8 June 1871, Archives of American Art, Smithsonian Institution, Washington, D.C., quoted in Zukowski 2001, p. 105: "A Feudal Castle which I am building— under the modest name of a dwelling house—absorbs all my time and attention." See also Gerald L. Carr, *In Search of the Promised Land: Paintings by Frederic Edwin Church*, exh. cat., Berry-Hill Galleries (New York, 2000), p. 102, on Church's references to Olana as a castle.

5. Zukowski 2001, pp. 42–43, 121–128; Carr 1994, pp. 9–10.

6. L. P. Hartley, *The Go-Between* (New York: New York Review of Books, 1953), p. 17.

7. F. N. Zabriskie, "'Old Colony' Papers, an Artist's Castle, and Our Ride Thereto," *Christian Intelligencer*, 10 September 1884: "The whole house is a museum of fine arts"; cited in Zukowski 2001, pp. 57–67; see also Carr 1994, p. 14.

8. Church to William Osborn, 4 February 1869, quoted in Zukowski 2001, p. 58, and in James Anthony Ryan, "Frederic Church's Olana: Architecture and Landscape as Art," in Franklin Kelly, *Frederic Edwin Church*, exh. cat., National Gallery of Art (Washington, D.C., 1989), p. 143.

9. Carr 1994, pp. 12, 273; David C. Huntington, "Frederic Edwin Church, 1826–1900: Painter of the New World Adamic Myth" (Ph.D. diss., Yale University, 1960; rpt. Ann Arbor, Mich.: University Microfilms International, 1969), pp. 13–14.

10. Charles Dudley Warner, "An Unfinished Biography of the Artist," typescript of an unlocated and unfinished original manuscript biography of Frederic Church, Olana State Historic Site, reprinted in Kelly 1989, p. 179.

11. Ibid., p. 177.

12. Ibid., p. 180.

13. Carr 1994, pp. 19–20; Huntington 1960, pp. 15–18.

14. Carr 1994, pp. 20, 60; Carr 2000, p. 21; Huntington 1960, pp. 18–20.

15. Church to Thomas Cole, Hartford, 20 May 1844, New York State Library, Albany, partially quoted in Carr 1994, p. 20.

16. Quoted in Warner, in Kelly 1989, p. 186.

17. Rev. Louis Legrand Noble, *The Course of Empire, Voyage of Life and other Pictures by Thomas Cole, N.A.*, (1853) quoted in Warner, in Kelly 1989, p. 186.

18. Thomas Cole to Frederick W. Mimée (a student applicant), Catskill, 16 December 1847, quoted in Carr 1994, p. 20.

19. Ibid., p. 37.

20. Carr 1994, pp. 75–76.

21. Ibid., p. 152. The development of Church's twilight subjects is well described in Franklin Kelly, *Frederic Edwin Church and the National Landscape* (Washington, D.C.: Smithsonian Institution Press, 1988), pp. 26–34, 77, 84–95, 102–122.

22. Carr 1994, p. 233. Carr believes the view is either Maine or South America, where Church made his first expedition in 1853. However, the mountains in the sketch seem far too remote and low to be the Andean cordilleras that Church visited in Colombia and Ecuador, and the sky effect seems too warm and dramatic for the relatively cool and abrupt sunsets and twilights that typify those in the Andes near the equator, as is discussed below in connection with cat. no. 4 (*Mount Chimborazo at Sunset*).

23. Church's religious persuasion, influences, and sympathies, and their connection to light spectacles in his paintings, are discussed in great detail in David C. Huntington, "Church and Luminism: Light for America's Elect," in John Wilmerding, ed., *American Light: The Luminist Movement*, exh. cat., National Gallery of Art (Washington, D.C., 1980), pp. 155–187.

24. Ibid., pp. 156–157. Huntington cites the liberal Calvinist preacher Horace Bushnell as particularly influential. Church owned a copy of Bushnell's *Nature and the Supernatural* (1858), as well as *Typical Forms and Special Ends in Creation* (1857) by Rev. James McCosh, a Scottish theologian at Princeton University.

25. John Ruskin, *Modern Painters*, vol. 4 (1856), quoted in ibid., p. 175.

26. Niagara's prime place in American landscape art and illustration is fully described in Jeremy Adamson, *Niagara: Two Centuries of Changing Attitudes, 1697–1901*, exh. cat., The Corcoran Gallery of Art (Washington, D.C., 1985); see especially the essays by Adamson, "Nature's Grandest Scene in Art," pp. 11–81; Elizabeth McKinsey, "An American Icon," pp. 83–101; and John F. Sears, "Doing Niagara Falls in the Nineteenth Century," pp. 103–115.

27. Joseph Earl Arrington, "Godfrey N. Frankenstein's Moving Panorama of Niagara Falls," *New York History* 49 (April 1968): 169–199. The length of the panorama is discussed on p. 175.

28. For illustrations of the coastal sketches, see Theodore E. Stebbins Jr., *Close Observation: Selected Oil Sketches by Frederic E. Church*, exh. cat., Cooper-Hewitt Museum, Smithsonian Institution's National Museum of Design (Washington, D.C., 1978), pp. 62, 63.

29. Carr 1994, pp. 230–233. The previous oil study, *Niagara Falls and Horseshoe Falls* (private collection), is illustrated on p. 233.

30. The clamorous public response to *Niagara* is described in Huntington 1960, pp. 85–90; and idem, *The Landscapes of Frederic Edwin Church* (New York: Braziller, 1966), pp. 1–4.

31. Church to A. C. Goodman, Clifton House, Niagara Falls, 24 September 1858, quoted in Carr 1994, p. 250.

32. *New York Times*, 8 December 1862, cited in Adamson 1985, p. 70; Carr 1994, pp. 250, 273; Huntington 1960, p. 33, cites Henry Tuckerman's *Book of the Artists* (1867), to the effect that Church painted *Under Niagara* "in seven hours from memory."

33. Humboldt's career and significance to both natural history and the career of Frederic Church are described authoritatively in Stephen Jay Gould, "Church, Humboldt, and Darwin: The Tension and Harmony of Art and Science," in Kelly 1989, pp. 94–107.

34. Gould, in Kelly, pp. 100–104.

35. Alexander von Humboldt, *Cosmos: A Sketch of a Physical Description of the Universe*, trans. E. C. Otté (London: Henry G. Bohn, 1849–59), vol. 2, p. 452: "Are we not justified in hoping that landscape painting will flourish with a new and hitherto unknown brilliancy when artists of merit shall . . . be enabled, far in the interior of continents, in the humid mountain valleys of the tropical world, to seize, with the genuine freshness of a pure and youthful spirit, on the true image of the varied forms of nature?"

36. Humboldt's "Geography of Plants" is illustrated and discussed in Kevin J. Avery, *Church's Great Picture: The Heart of the Andes*, exh. cat., The Metropolitan Museum of Art (New York, 1993), pp. 14, 15, fig. 6; Alexander von Humboldt, *Researches, Concerning the Institutions & Monuments of the Ancient Inhabitants of America, with Descriptions & Views of Some of the Most Striking Scenes in the Cordilleras!* trans. Helen Maria Williams (1814), quoted in Carr 1994, p. 246.

37. Carr 1994, pp. 245–246.

38. Alexander von Humboldt, *Researches Concerning the Institutions and Monuments of the Ancient Inhabitants of America, with Descriptions and Views of Some of the Most Striking Scenes in the Cordilleras!* trans. Helen Maria Williams (London: Longman, Hurst, Rees, Orme and Browne, J. Murray and H. Coburn, 1814), vol. 1, p. 238.

39. For the debut and exhibition tour of *The Heart of the Andes*, see Huntington 1960, pp. 1–12; idem 1966, pp. 5–9; Avery 1993, pp. 34–44; and Gerald L. Carr, "American Art in Great Britain: The National Gallery Watercolor of *The Heart of the Andes*," *Studies in the History of Art* 12 (1982): 87–95.

40. Carr 1994, pp. 247–249.

41. I am grateful to Dorothy Mahon, Paintings Conservator at the Metropolitan Museum of Art, for pointing out the pentimenti to me.

42. A thorough account of the creation and reception of *The Icebergs* is Gerald L. Carr, *Frederic Edwin Church: The Icebergs*, exh. cat., Dallas Museum of Fine Arts (Dallas, 1980). See also Eleanor Jones Harvey, *The Voyage of the Icebergs: Frederic Church's Masterpiece* (Dallas: Dallas Museum of Art, 2002).

43. Carr 1994, p. 222; Huntington 1960, pp. 156–157.

44. Carr 1994, pp. 273–274.

45. Church to Mr. Field, New York, 22 April 1865, typescript of a letter, Olana Research Collection, partially quoted in Carr 1994, p. 274.

46. The oil sketches of Jamaican mountains, including cat. no. 9, are described and discussed in Carr 1994, pp. 294–295, nos. 428–432. For others, in the Cooper-Hewitt, National Design Museum, see Stebbins 1978, pp. 35–38, 82–87.

47. The oil sketch is no. 424 in Carr 1994, p. 290, and is discussed in no. 426, p. 291.

48. Church to J. B. Austin, Galloway Hill, Jamaica, 14 August 1865, typescript, Olana Research Collection.

49. Church to Charles de Wolf Brownell, Hudson, 6 November 1893, quoted in Carr 1994, p. 291.

50. Ibid., p. 291.

51. Frederic Church to Joseph Church, "Farm," 3 October 1867, quoted in Carr 1994, p. 293.

52. Ibid., no. 427, pp. 292–294.

53. Carr 1994, pp. 286–287; Huntington 1966, pp. 61–62; Kelly 1989, pp. 62–63.

54. Carr 1994, p. 303, no. 464, pp. 311–317.

55. Church both signed his letters with sketches of churches and punned his name in the text. For examples of both, see Christopher Kent Wilson, "The Landscape of Democracy: Frederic Church's *West Rock, New Haven*," *American Art Journal* 43, no. 3 (summer 1986): 24, 26, figs. 7, 8.

56. Carr 1994, p. 311; see also Joyce Zucker and H. Travers Newton, "The Examination and Treatment of Church's *The After Glow*," in ibid., pp. 513–521.

57. Church to J. B. Austin, Galloway Hill (Jamaica), 14 August 1865, quoted in Carr 1994, p. 296.

58. Ibid., no. 248, pp. 163–166; Kelly 1989, p. 43.

59. *Blueberry Hill, Vermont* is discussed in Carr 1994, pp. 296–297; for other Vermont oil sketches, see Stebbins 1978, pp. 15, 56, 57.

60. A drawing of Pichincha, dated 26 June 1857, is illustrated in Avery 1993, p. 26, fig. 15.

61. Carr 1994, p. 304.

62. Carr 2000, p. 95.

63. Carr 1994, p. 303.

64. In May 1869, from Paris, Church wrote to his friend, Erastus Dow Palmer, that, following his excursion to Athens, he "returned to Rome with its gross Architecture—[it] looked cheap and vulgar," and added that he "was glad to get away from the Italians." Church to E. D. Palmer, Paris, 14 May 1869, quoted in Huntington 1960, pp. 185–186.

65. The most authoritative recent discussion of the Anglo-American community in the Holy Land and Church's interaction with it is John Davis, *The Landscape of Belief: Encountering the Holy Land in Nineteenth-Century American Art and Culture* (Princeton: Princeton University Press, 1996), especially chap. 2, pp. 27–52, and pp. 173–174. See also Carr 2000, p. 87; Huntington 1966, pp. 56–59.

66. Phelps quoted in Davis 1996, p. 185.

67. Diary of Isabel Carnes Church, 28 March 1868, quoted in ibid., p. 188.

68. Ibid., p. 173; Carr 2000, pp. 88–89; Carr 1994, pp. 303, 319, 320–323, 387–390.

69. Church to E. D. Palmer, Jaffa–Palestine, 24 February 1868, quoted in Carr 1994, p. 390; and Huntington 1960, p. 169.

70. Church to William Osborn, Perugia, 29 September 1868, quoted in Carr 2000, p. 90; and Davis, p. 174.

71. Carr 1994, p. 321.

72. David Roberts and Rev. George Croly, *The Holy Land, Syria, Idumea, Arabia, Egypt, & Nubia* (New York: D. Appleton, 1856).

73. Church to E. D. Palmer, Jaffa–Palestine, 10 March 1868, quoted in Carr 1994, p. 322; and Huntington 1960, p. 169.

74. Church to William Osborn, Jerusalem, 1 April 1868, quoted in Carr 1994, p. 390.

75. Church to E. D. Palmer, Jaffa–Palestine, 10 March 1868, quoted in ibid.

76. Kevin J. Avery, "*The Heart of the Andes* Exhibited: Frederic E. Church's Window on the Equatorial World," *American Art Journal* 28, no. 1 (winter 1986): 54–55.

77. Church to William Osborn, Jerusalem, 1 April 1868, quoted in Carr 1994, p. 390, and in Davis 1996, p. 194.

78. Carr 1994, p. 304; Carr 2000, pp. 90–91; Huntington 1960, pp. 178–179; Stebbins 1978, pp. 41–42, 94–97.

79. Church to William Osborn, Berchtesgaden, 29 July 1868, typescript, Olana Research Collection.

80. Ibid., quoted in Carr 2000, p. 90; Davis 1996, p. 174.

81. The oil sketch's possible connection to *Rainy Season in the Tropics* is made in Carr 1994, p. 329.

82. Carr 2000, p. 96; Carr 1994, p. 341.

83. See also Carr 1994, pp. 342–343, on Church's perception of Olana on the Siengenbergh in relation to the Parthenon on the Acropolis.

84. Church to William Osborn, Athens, 14 April 1869, quoted in Carr 1994, p. 342; and Carr 2000, p. 96.

85. The painting of the olive tree grove is discussed in Carr 1994, pp. 343–344.

86. Church to William Osborn, Berchtesgaden, 29 July 1868, Olana Research Collection.

87. Carr 1994, p. 369; and Carr 2000, p. 105.

88. Carr 1994, p. 378.

89. Ibid., p. 379.

90. Church to E. D. Palmer, Hudson, 19 August 1872, quoted in ibid., p. 382.

91. St. Paul's Epistle to the Hebrews (3:4) quoted in W. L. Whipple to Church, 4 March 1888, quoted in Zukowski 2001, pp. 119–120.

92. Church to E. D. Palmer, Hudson, 7 July 1869, quoted in ibid.; Carr 2000, p. 100; Huntington 1966, p. 114; Huntington 1960, p. 194.

93. Church to E. D. Palmer, Hudson, 22 September 1869. For Church's condition, see also Carr 1994, pp. 305, 370, 405, 419–423, 466–469.

94. [G. Willard Shear], *Panorama of the Hudson Showing Both Sides of the River from New York to Albany . . . Photographed by G. Willard Shear* (New York: Bryant Literary Union, 1888), n.p.

95. The Mexican travels are described in Carr 1994, pp. 419–423, 466–469. Isabel's ailments are unclear. She suffered chronic symptoms of "fatigue, headache, insomnia, and general malaise" that suggest a psychological as much as physiological source. See Zukowski 2001, pp. 92–93.

96. "Diary of Emma Carnes," 9 November 1884, quoted in Carr 1994, p. 421; Howard Russell Butler to his father, Cuautla, 14 March 1884, quoted in ibid.

97. Ryan, in Kelly 1989, p. 146.

98. Carr 1994, p. 471.

99. Barbara Dayer Gallati, "Kindred Spirits," in John K. Howat, *American Paradise: The World of the Hudson River School*, exh. cat., The Metropolitan Museum of Art (New York, 1987), p. 110.

100. Church to E. D. Palmer, Olana, 28 December 1890, Olana Archives, partially quoted in Carr 1994, p. 466: "I have been anxious to paint three or four pictures—not large ones—for my family—for I have not nearly enough of finished works to go around."

101. Carr 1994, pp. 466, 471, discusses the two pictures as "antithematical."

102. Kate Bradbury to an unidentified correspondent, 24 December 1889, quoted in Davis 1996, p. 204.

103. Darwin's contradiction of Humboldt's—and therefore Church's—worldview is well summarized by Gould in Kelly 1989, pp. 104–106.

104. Church to Thomas G. Appleton, Olana, 1 May 1883, quoted in Davis 1996, p. 204.

This book and the accompanying exhibition were made possible in part by generous gifts from the following:

Jan P. and Warren J. Adelson
The Beulah Land Foundation
The Cape Branch Foundation
The Felicia Fund
David B. and Mimi G. Forer
Valerie and Brock A. Ganeles
Frederick D. Hill
Carol Irish
Gretchen and James L. Johnson
Mark LaSalle
The Henry Luce Foundation
The Lucelia Foundation
The Lunder Foundation
Peter and Paula Lunder
Pauline Metcalf
Richard and Elizabeth Gosnell Miller
The New York State Council on the Arts
Susan and Washburn S. Oberwager
Louis M. Salerno
The Strabo Council
Eli Wilner & Company, NYC
Susan Winokur and Paul Leach

The Trustees and staff of The Olana Partnership also wish to recognize the support of Governor George E. Pataki, New York State Office of Parks, Recreation and Historic Preservation Commissioner Bernadette Castro, Deputy Commissioner for Operations for the Hudson Valley James Moogan, Taconic Regional Director Jayne McLaughlin, and Olana Site Manager Linda E. McLean.

THE HENRY LUCE
FOUNDATION

State of the Arts

NYSCA

Supporting Olana

The Olana Partnership was founded in 1971 to assist and support New York State in the restoration and preservation of Olana. We rely on a large number of supporters—individuals, foundations, companies, and public sector sources—to fund our work for the enhancement of Olana and its integral viewshed, to sponsor educational programs, and to foster scholarly research on the artist and his property. This support is essential to Olana's education, outreach, and public programs, to care for the collection, and to support lending from and exhibitions of the collection. Your donation will make a real difference and enable others to enjoy Olana both now and into the future. For more information on how you can help, please contact The Development Office, The Olana Partnership, PO Box 199, Hudson, NY 12534 or visit us at www.olana.org.

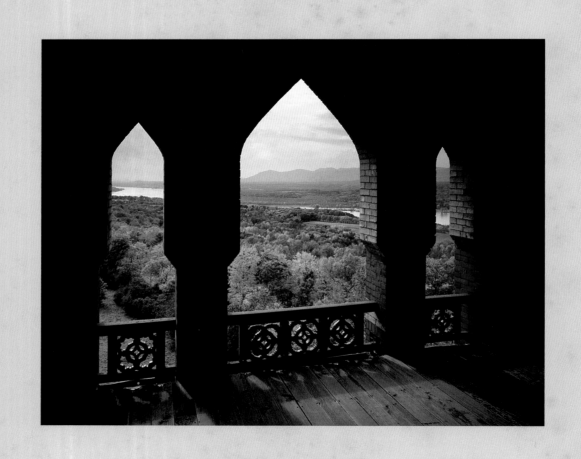

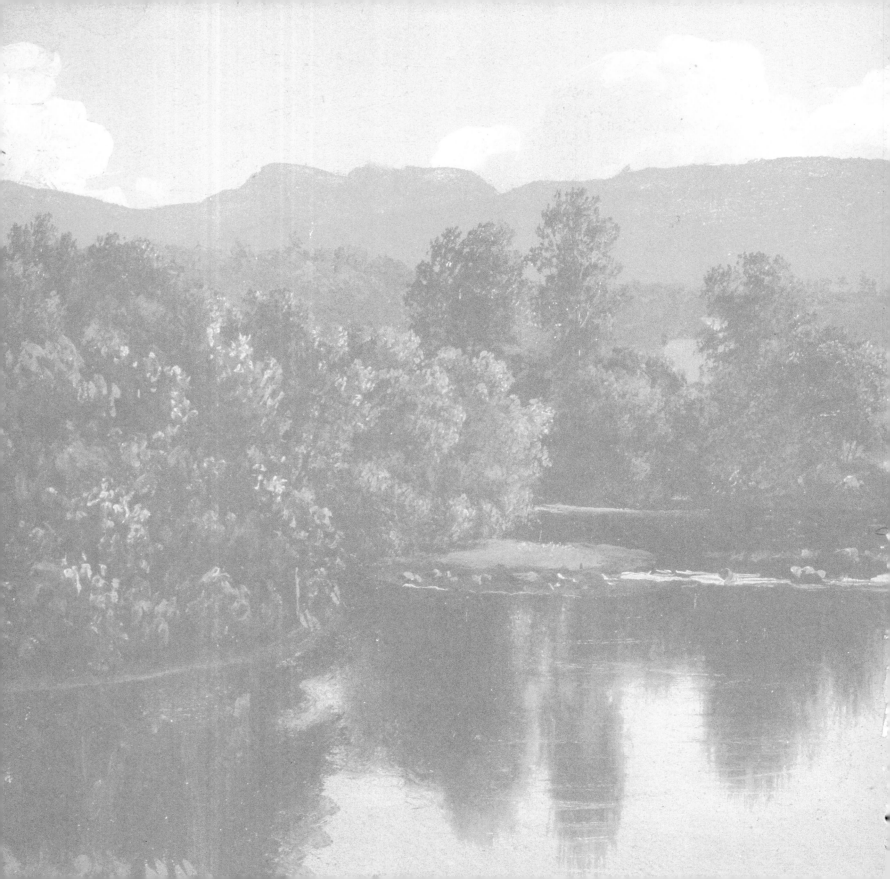